T H E
PORTRAIT

Professional Techniques and Practices in Portrait Photography

The Portrait—Professional Techniques and Practices in Portrait Photography

Writing contributions by:
*Don Blair, Frank Cricchio, Joe Marvullo, John and
Trish Perrin, Denis Reggie, Ted Sirlin, and Jeff Wignall*

Front cover photo:
©Michael G. Taylor

Back cover photo:
©Stuart Williamson

Publication O-24
CAT No. E102 1443
Library of Congress Catalog Card Number 95-68105
ISBN 0-87985-513-4

6-95 Minor Revision
Printed in the U.S.A.

*The Kodak materials described in this book are available
from those dealers normally supplying Kodak products.
Other materials may be used, but equivalent results
may not be obtained.*

KODAK is a trademark of Eastman Kodak Company
used under license.

EASTMAN, EKTAR, VERICOLOR, EKTACOLOR, GOLD,
T-GRAIN, PRISM, WRATTEN, ESTAR, T-MAX, PLUS-X,
ELITE, DURATRANS, DURACLEAR, and DURAFLEX are
trademarks of Eastman Kodak Company.

Editor's Note: *Some of the information and conclusions
presented by the authors of this book are based on their
own methods and experiences. Eastman Kodak Company
accepts no responsibility for results derived from nonstandard
uses of Kodak products. Readers should evaluate the utility
of the information for their own applications.*

KODAK Books are published under
license from Eastman Kodak Company by
Silver Pixel Press
21 Jet View Drive
Rochester, NY 14624
Fax: (716) 328-5078

CONTENTS

THE BUSINESS OF PORTRAIT PHOTOGRAPHY 4
BY TED SIRLIN

Photographic Specialty and Style
Attracting Inquiries
Converting Inquiries into Sittings
Building Repeat Business
Selling
Staffing Needs
Outside Assistance
Establishing Sound Business Principles
The Morning Meeting
Your Business Plan
The Competition
Seize the Opportunities

EQUIPMENT .. 16
BY JEFF WIGNALL

Choosing a Camera Format
Medium-Format Cameras
35mm Cameras
Large-Format Cameras
Lenses for Portrait Photography
Instant Proofing—The KODAK PRISM Electronic
 Previewing System
Lighting Equipment
Filters
Backgrounds
Light Meters

EXPOSURE AND LIGHTING TECHNIQUES 28
BY FRANK CRICCHIO

Step 1: Select the Equipment
Step 2: Determine the Correct Exposure
Step 3: Determine the Lighting Ratio
Step 4: Establish a Working Film Speed
Step 5: Determine Exposure Indexes for Other
 Lighting Conditions
Step 6: Understand and Use Appropriate Lighting
 Techniques for Portraiture

MAKING PORTRAITS ... 44
BY JOE MARVULLO

Establish Rapport
Evoke Personality
Bring Out the Best
Create the Atmosphere
Make It Contemporary
Prop It
On Location
Outdoors

SPECIALTY PORTRAITS .. 60
BY DON BLAIR

The Executive Portrait
Environmental Portraits, Family Groups,
 Couples, and Pets
Babies and Children
Teenagers and High School Seniors
Group Portraits

WEDDING PHOTOGRAPHY 74
BY DENIS REGGIE

Traditionalist Versus Photojournalist
Equipment
Film
Lighting Techniques
Preparation
Pre-Ceremony Coverage
The Ceremony
Formal Photographs
The Reception
Follow-Up

FASHION MAKE-OVERS .. 92
BY JOHN AND TRISH PERRIN

Before and After
The Session
Back in the Studio
Reality and Illusion
Why Illusion?
How it Starts
The Fun Begins
When They Look Beautiful, They Feel Beautiful
Behind the Camera
Lighting
Diffusion
Image Styling
Boudoir Photography
Fashion/Art Black and White
Limited Edition Black and White
Euro-Style Black and White
Photographing Men

PRESENTING PORTRAITS ... 112
BY DON BLAIR

The Preview Presentation
Retouching Portraits
Mounting and Matting Portraits
Framing Portraits
Special Presentation Techniques
Display Considerations

THE BUSINESS OF PORTRAIT PHOTOGRAPHY

BY TED SIRLIN

*So you're thinking of opening a portrait studio? Great idea!
It may also be a terrible idea, unless you are prepared with the education, experience, temperament,
and the ability to succeed in a highly-competitive, demanding enterprise. You must be
ready to make a total commitment.*

What experience should you bring to this venture? The best experience comes from working for a successful studio. Learn about how the studio became successful by observing the management style, reading the marketing plan, and, above all, studying the people-to-people skills being used.

Let's assume you have decided to open a studio. Where should you begin?

After assessing your experience, skills, resources, personality style, and goals, determine the type of photography you want to offer to the public. If you are in a large urban area, you may want to specialize. If you are planning to settle in a small or rural area, you may prefer to offer a broader range of services to meet the needs of the community.

Adopt a game plan. You should ask yourself the following questions:

- *What kinds of services and types of photography will you offer?*
- *How will you attract attention and elicit inquiries?*
- *How will you convert inquiries into sittings or assignments?*
- *How will you build repeat business and establish your reputation?*
- *What are the appropriate sales techniques you will practice?*
- *What will staffing needs be—initially and after the business grows?*
- *What outside assistance will your require?*
- *How will you establish sound business principles for you and your employees?*

- *How often should you and your staff meet to plan, organize, and review business matters?*
- *Will you write a business plan?*
- *Do you know who your competition is and what they are doing?*

There are certainly more elements to consider in a game plan, but these are some of the most important ones. Let's examine them in more detail.

Photographic Specialty and Style

The client is king. You should determine which photographic services and types of photography is selling in your area, which are desired, but not available, and which ones you may introduce that will sell. Most studios in the United States depend upon wedding and school pictures for the bulk of their revenue. Since the competition is keen in those areas, most novices find it hard to compete profitably. In any event, a broader basis of income will provide more security and more profit for most studios.

Vincent M. Palazzolo

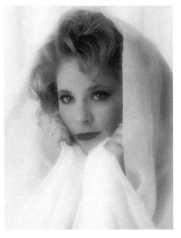

The drape over the subject's hair and the high-key treatment focus attention on the subject's face and eyes in this expressive portrait.

4

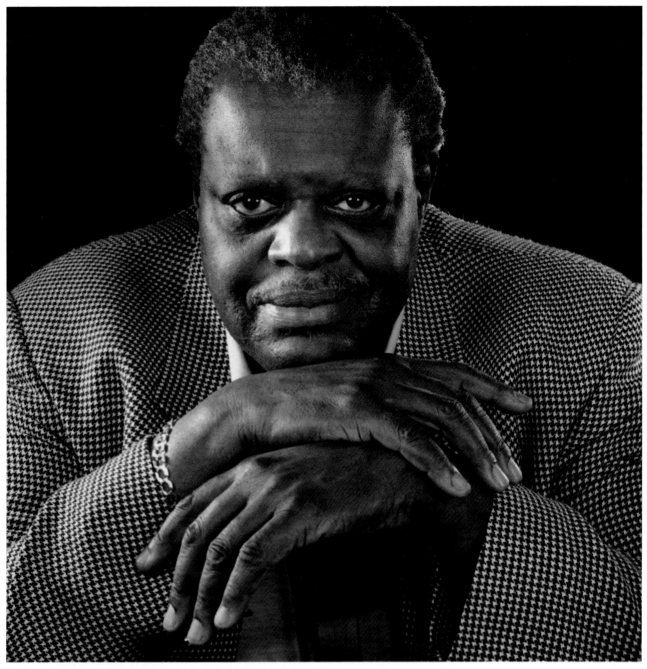

The strong appeal of black-and-white portraiture is clearly conveyed in this dramatic close-up of jazz pianist Oscar Peterson. Al Gilbert, F.R.P.S.

The common mix offered by many successful studios include family, children, business, and event photography, plus copies and restorations, and the sale of picture frames. By diversifying in at least these product lines and treating each as a profit center, it becomes possible to compare the desirability of each category. You may want to compare the performance of each area on a regular basis. Consider dropping the least rewarding line and concentrating your resources and efforts on the more favorable areas. Or you may wish to examine your least successful line to see what you can do to improve it.

Sirlin Photographers

Attractive print displays in public locations and in your reception area can lead to increased inquiries from your clients.

Styles change, tastes change, fashions change, and trends in photography change. Consumers, particularly those of school age and early twenties, are extremely style conscious. They will recognize when a photographer is not current and when sample prints are shown with last year's hair and clothing styles. Study fashion magazine and TV ads, particularly those promoting cosmetic and hair product. These advertisements are usually a good indication of the coming trends. There are fashion conscious clients and those who have more conservative tastes. Learn who you are serving and offer the appropriate photographic styles.

Attracting Inquiries

Attracting inquiries will be an ongoing challenge throughout your career as a photographer. In the beginning, you will find it desirable to invest in advertising to tell consumers why they need your services. Your ads should clearly communicate that your services are the top quality available in your community. Seek editorial advertising (unpaid) by telling your story to newspaper and magazine editors and radio station disk jockeys. Open houses, talks before civic groups, displays in public places and in your studio reception room will all result in increased inquiries by potential clients. Become involved in the community by volunteering your time to service and civic organizations.

Regardless of price, there must be value. If your prices are higher than someone who is offering a better product or service, you will need to increase your quality or decrease your prices.

Start a mailing list from as many resources as you can find. For your grand opening, you may wish to send an introductory offer by direct mail to the entire community or to selected areas by zip code.

At this stage, it is imperative to determine the image that you want to project to the community concerning your style, pricing, and product lines. Do not confuse the public with inconsistencies. Your location, furnishings, general decor, logo, stationery, type styles, advertising, personal grooming, work quality, and pricing must all complement each other. The public can support both mass merchandisers and exclusive specialty shops because people have come to expect a certain level of consistency from each. But if you present your clients with high prices and poor grooming, inferior displays, or anything but the best quality, they will recognize the inconsistencies and go elsewhere.

Regardless of price, there must be value. If your prices are higher than someone who is offering a better product or service, you will need to increase your quality or decrease your prices. If you do nothing, you will lose market share and eventually fail. Consumers are more-informed and better-educated buyers than ever before. Your staying power in today's marketplace will be determined by each customer's perception of the value you offer them.

Converting Inquiries into Sittings

Many studios receive lots of inquiries but end up with few sittings. There are many reasons, but most relate to poor communications. Often we are so wrapped up in sizes, finishes, and pricing, that we fail to recognize our responsibility to our clients. They are interested in obtaining the best possible photograph of themselves. Each client has a different need, a different viewpoint of how they look or wish to look, and a different personality It is important to discuss these details with them so that you can custom design the portrait to meet their expectations. Some clients may be better served by having the photograph made in their home or office. Others may be more comfortable in a park or backyard environment. Some may prefer the studio sitting. Review the desired style of photography with your client while showing sample prints that illustrate contemporary, traditional, or classic approaches.

The purpose of the photograph is very important, too. It may be a portrait gift to a mother or a lover. The client will probably wish to convey a specific feeling to the receiver of the portrait. Perhaps the client is seriously ill and fearfully anticipating surgery. This can be an emotional experience; he or she may be thinking that this is a final portrait or at least the last one that reflects reasonably good health. We need to be sensitive to each emotion and to each need.

It is unthinkable for a surgeon to operate on a patient without knowing exactly what needs to be done to help the patient. Yet we find photographers taking portraits of individuals without ever having any idea of what style the customer wants or needs.

We need to listen! Since most studio inquiries originate by phone, it is an absolute requirement that the person who answers the phone is qualified. The person must be a good listener, have a pleasant voice, speak with enthusiasm, and have a fair amount of product knowledge.

The telephone is the studio's most important piece of equipment. The person answering the phone may be the most important influence upon the success or failure of the entire enterprise.

It is not an exaggeration to say that a client's opinion of an entire studio can rest on the initial phone conversation. There are many skilled photographers who have gone out of business because they didn't understand the powerful role the telephone plays in our business.

The average studio is generating less than half of their potential revenue if they are presently misusing the phone. Unfortunately, the phone answering responsibility too often is relegated to the least-qualified person rather than the most-qualified person available.

There are a variety of needs that prompt a potential client to telephone a portrait studio. They may call because they are looking for a gift for someone dear. They are planning on a special gift of a portrait for the same reason they call or visit the jeweler, the candy store, the florist or any other type of gift store. They are seeking a tender communication of their love. They may wish to preserve the memory of a happy occasion such as an anniversary. They may wish to preserve a precious moment in time such as a fourth- or fifth-generation family portrait. Or, perhaps a child is leaving for service in the armed forces and this is the last time the family portrait can be taken while everyone is together.

David W. Stauffer, Leichtner Studios

A staff member with a good understanding of current makeup techniques and styles can be invaluable.

These are extremely emotional experiences. Many times when potential clients call to make an appointment for this important portrait, they ask "How much is an 8 x 10?" The unqualified person answering the phone usually talks about prices, sizes, and finishes, not recognizing that those items are really insignificant at this point in the conversation. What the caller is really seeking is someone who is sensitive to the emotions that

precipitated the reason for wanting this portrait. They are seeking someone who will anticipate their fears and reassure them.

Will I be happy with the portrait? Will it be a pleasant experience? What shall I wear? Will I receive it in time for the special anniversary? Is this an appropriate gift? Am I calling the right studio?

How will the inquiry be answered? The qualified person responding to the phone inquiry will recognize the importance of establishing a rapport with the client in the first 20 seconds. The client must sense that he or she is talking to an interested, sensitive, caring person—a person who listens, who asks questions, who gets involved, who offers advice, and who is cheerful and enthusiastic.

As the conversation progresses, the person answering the phone will sense the customer's specific fears, will determine the customer's needs, will reassure the customer and will ultimately make a friend.

Let's explore the questions you can ask the next person who calls, keeping in mind the reason for any question is to help the client be properly prepared for having a portrait made.

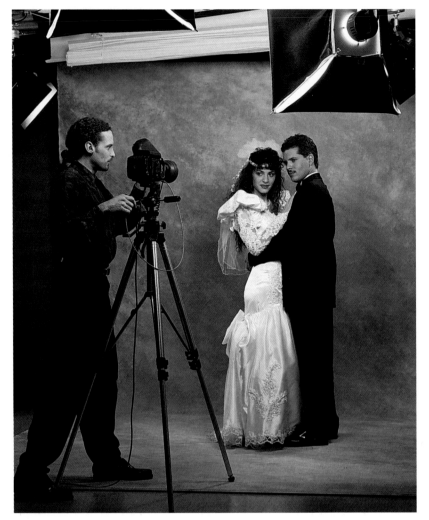

Photo sessions progress much more smoothly if you have taken the time beforehand to understand your client's needs and emotions.

Karin B. Weber, Leichtner Studios

The qualified person responding to the phone inquiry will recognize the importance of establishing a rapport with the client in the first 20 seconds.

- *What do you plan to wear for the portrait?*
- *Shall I come to your home so you can show me the clothes and accessories you are considering wearing for the portrait?*
- *Should we make the portrait in your home?*
- *Will you be giving the portrait as a gift?*
- *Will you be hanging the portrait on your wall?*
- *Do you feel you look better in the morning or later in the day?*

- *If you are having your hair styled, how long after being styled does it look the best?*
- *Would you like to come in so we can show you samples of various styles of portraits available to you?*
- *Would it be possible for you to show me some of your existing portraits so that I can see how you look in photographs?*
- *Perhaps you might point out some features that you particularly liked or disliked in the portraits?*

In following this line of questioning you will be photographing a person who will be properly prepared, cooperative and supportive during the portrait session, and appreciative and, most likely, thrilled with the results.

Building Repeat Business

You will find that you must earn repeat business and that it is possible with very little investment. You might think about the repeat business opportunities in special-offer mailings to past customers, but these mailings only remind customers of your existence.

Repeat business begins with the original sale. Was the client treated fairly? Was value received? Was it a pleasant, cordial experience? Did you deliver what you promised? Was it delivered on time? Did you pay as much attention and care to the client when they left with the finished order as you did at the time of their initial visit? Did you thank them for their business at various times? Did you inform them that their negatives are on file and that they can place reorders by phone? Did you advise them that your work is guaranteed in any case of dissatisfaction or even disappointment?

Did you suggest that they show the prints to their neighbors and associates at work before giving their portrait to the recipient? Did you give them some business cards to distribute for you? Did you phone them a few weeks after delivery to ask about the reaction to the gift portrait?

Of course, there are many valid programs such as direct mail advertisements, birthday cards, form letters, and other merchandising strategies. Most are common and effective. What is not common these days is a sincere interest in providing quality service.

Linda Bass

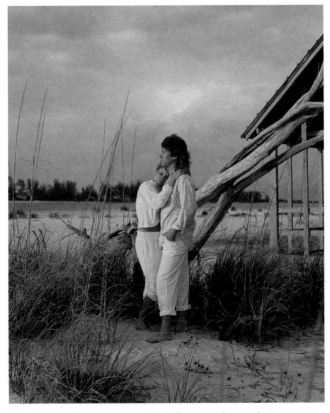

Working outside presents special challenges and rewards. For many portrait businesses, the ability to shoot on location is key to their success.

Jeff Lubin

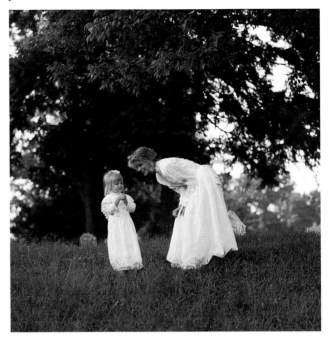

A specialty such as fine children's portraiture offers many profitable marketing opportunities.

My most effective repeat business activator has been this guideline: "Try to perform one extra little service of some kind for extra client today."

It works. It may be as simple as providing an umbrella and accompanying a client to his or her car on a rainy day.

Selling

Assuming you have a good product and offer fair value, you would imagine that you'd enjoy reasonable sales. Not true! Too many sales people are more interested in the sale rather than in fulfilling the client's needs and wants. Too many sales people do not listen. Too many sales people are practicing sales techniques instead of practicing the golden rule. By treating your clients as you would want to be treated, you avoid the salesperson-buyer adversarial relationship and you establish the helper-friend relationship. If you have a sincere interest in the client, the client will buy.

Duane Sauro

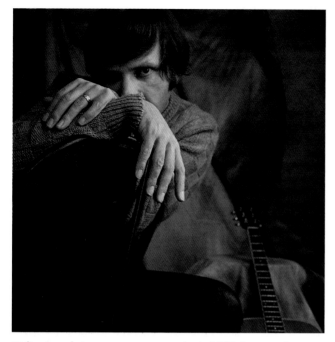

Delivering what your customers want is vital. This introspective image was designed as an album cover for this client.

If you tell the truth, the buyer will listen favorably to your suggestions. Often, you will have to explain appropriate sizes depending upon where the portrait will hang. You may wish to find out who the buyer is considering for gift purposes. Suggest proper framing. Ask about other photographic needs coming up during the year. Perhaps there will be a family reunion, an anniversary, a birthday or other significant event.

The opportunity for sales is endless, and you will earn the opportunity to serve some of those needs if you treat your clients fairly, give them value, avoid high pressure, and look upon the current transaction as the first of many pleasant experiences for you.

Staffing Needs

At some point you will find that you can increase your business if you have the help of staff. Each new employee will become an extension of yourself—a new person you can train to share or assume many of your responsibilities. At this point, you are no longer the business. The business is now a composite of many new talents and personalities. Whether additional staff becomes a positive or a negative influence on the success of the operation depends upon several factors.

The most important factor is the interview and the selection process. All too often, an employee is hired

because the studio is frantic in an hour of need and a careful selection process was not undertaken. This is generally a costly mistake. Why accept a person who may have high abilities but lacks integrity? The problems that will follow are predictable.

The interview procedure should be well thought out. You need to establish your list of priorities. You are going to invest in and depend upon this new person. The characteristics to look for during the interview are:

- *Integrity* *Stability* *Enthusiasm*
- *Attitude* *Working habits* *Grooming*

The next step in building a staff is the training process. Whether the new addition is a photographer, sales person, lab technician, or bookkeeper, the principle of training is the same. You can teach the necessary skills to people of average intelligence who have the characteristics mentioned above along with basic aptitude, education, average ability, and high motivation.

You must also provide good leadership. The effective leader is sensitive to individual needs and problems, and supportive during a crisis by listening and responding, and remaining calm. The success or failure of the employee will generally depend more on your attitude than on that of the employee. To effectively motivate him or her, you must provide the employee with a sense

All too often an employee is hired because the studio is frantic in an hour of need and a careful selection process was not undertaken. This is generally a costly mistake.

of importance, personal dignity, self respect, and meaningful recognition. A leader is the ultimate optimist. He or she exhibits great enthusiasm and creates opportunities rather than obstacles to employee growth. Nature's law dictates that fish grow only in proportion to the tank that contains them. Your job is to provide the biggest tank—the widest latitude in responsibility—to allow maximum growth. You will find that your employees' true concern with your business will be proportional to your honest concern for them as individuals. Your employees are your business. Let them know it.

Outside Assistance

You may wish to establish a formal or an informal Board of Advisors. These may be other business people or your peers in the photographic business. It is desirable to have some outside advisors who bring skills from other fields with them.

There are numerous courses offered at community colleges or on a state college level. You will find these courses along with seminars important to your growth as a entrepreneur.

The U.S. Small Business Administration publishes numerous pamphlets. Each publication concentrates on a specific topic. Write to the SBA for a list of their publications.

By joining your local, state, and national photographic associations, you will broaden your sources of advisors. You will find an enormous sharing of information in programs being presented by leaders in various specialties. The greater benefit is in meeting

Doug Hoffman

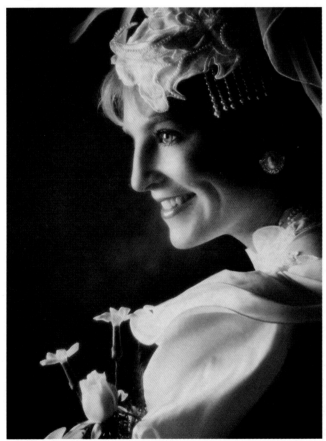

Most studios in the United States depend upon wedding and school pictures for the bulk of their revenue.

and establishing friendships with others having similar problems. Many times, you will find a solution to your particular problem while joining other members at breakfast or in after-hours socials.

Establishing Sound Business Principles

As you grow, you will find a policy manual valuable in helping you solidify your policies and procedures. *The Professional Photographers of America* (PP of A) *Policy Manual* may be a useful guide. There are also other guides sold in bookstores and through direct mail publishers. You probably are carrying guidelines in your brain. Translating them to paper is a natural step.

Your policy manual should address the following:

- *A brief history of your company, how it is organized, your business philosophy, and company expectations.*
- *Recruiting and hiring policies. Training and orientation information. Expectations of employees, such as dress policy, smoking rules, ethics, and use of company equipment.*
- *Employee classifications and categories, job descriptions, performance review policy, and advancement opportunities.*
- *Employee benefits, such as holidays, vacation and sick leave, insurance, profit sharing, parking privileges, discounts, special award programs, and expense allowances.*
- *Hours of operation, definition of work day, rules regarding punctuality, tardiness, and absences. Break and meal periods, time-keeping requirements, pay days, and leave-of-absence or time-off policies.*
- *Standards-of-performance, disciplinary procedures, and termination policies.*
- *Safety issues.*
- *Statements regarding your right to revise policies, right to terminate at will, employee rights under Equal Opportunity laws, and commitment to compliance with federal and state employment laws. Acknowledgment-of-receipt statement.*

You should review your policy manual with your legal counsel to be sure that it does not conflict with governmental regulations. This manual should be updated regularly as policies become out-dated and as new regulations take effect.

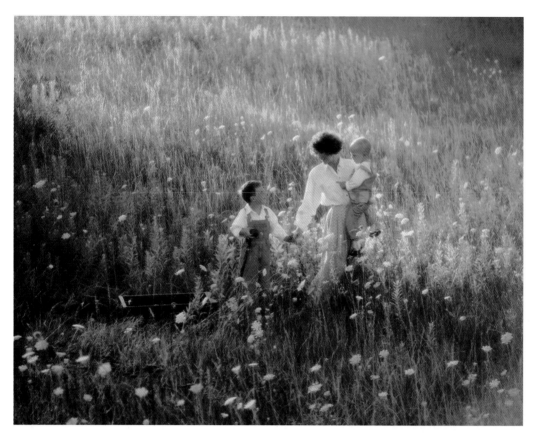

A diverse mix of products lines allows you to treat each one as a profit center. This makes it easier to evaluate profitability on a regular basis.

© Marijane Scott Smith

meetings each morning at 8:45 a.m. We don't schedule studio sittings until 9:15 a.m., so that we have 20 to 30 minutes available.

We may discuss a future promotion, a price change, or we may brainstorm. We regularly discuss telephone and sales procedures. There is never too much refinement when it concerns the use of the telephone. Each day, we review all of the day's appointments. For repeat clients (80 percent of our business), we pull the previous files and review them. This can give us information about the types of photographs the customer requested, their comments about the previews, their frequency of business with us, and many other facts that will help us serve them better. We also review the day's appointments of clients coming in for preview selection, pre-sitting conferences, delivery of finished orders, and any other type of visitor.

These morning meetings allow us to schedule our staff time based on needs, disseminate information that will make each day run smoother, greet our visitors by name, and avoid problems caused by lack of planning.

Even if you work alone, it is beneficial to dedicate a quiet time of 20 minutes or so for your own planing session daily. It will determine whether your business is running you or you are running the business.

You should hold other regularly scheduled meetings with your insurance broker and your banker (annually) and your accountant (quarterly or semi-annually).

A separate procedure manual will also be helpful. Set up a page for each procedure you establish. It will be a great help in training new people. You may have a page on how to write up an order and one on how to file negatives. Set up a page for scheduling dates for previews, finished work, reorders, and other scheduling needs. Detail how to record deposits, payments, cash transactions, and other bookkeeping functions.

The procedure manual is a record of how you wish things done. Review it for change and refine it on a regular schedule, perhaps monthly.

The Morning Meeting

I have found the daily, morning meeting to be the most useful tool in our studio for organizing the day, reviewing the previous day's business or problems, and anticipating the needs of the day or the week.

The size of your staff should not be a consideration of whether or not to schedule a meeting. You might meet with only one employee or with a dozen. We have our

Your Business Plan

We look upon ourselves as professionals because we have acquired knowledge in our field and have chosen it as our career. There are other professionals in other fields who can assistance us in many ways. I'll outline some of the important ones.

Insurance

Retain an insurance broker to advise you on the various insurance protection you will need, such as worker's compensation, liability, automobile, stock, customer goods in your possession, business interruption, fire, camera floater, health and medical-plan, and numerous other policies that may be important. A good broker will recommend appropriate coverage and will be of help in case of a loss.

Attorney

You may feel you do not need to retain a business attorney, but it would be wise to consult an attorney in starting your business. An investment of a short, initial consultation may help prevent unanticipated problems and will serve the purpose of establishing a relationship for future needs.

Accountant

Set up your business on an accounting basis that is beneficial to you based on the size of your investment, the source of your funds and the projected profits. You

© John Drew

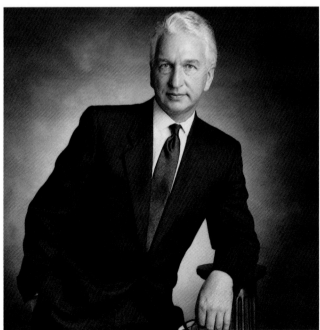

Executive portraiture is important to most corporations, and it provides many opportunities for photographers who recognize this need of industry.

may operate as an individual proprietor, a Subchapter S corporation, or a partnership. You need to establish whether you will operate on a cash or accrual basis. Your accountant will advise you about the necessary filings with government agencies, set up a timely tax payment plan, and consult with you on many other start-up requirements.

Set up your business on an accounting basis that is beneficial to you based on the size of your investment, the source of your funds and the projected profits.

Banker

If you start with adequate capital, you may not have an immediate need to establish a banking relationship, but it is quite necessary. Vendors will require a bank reference to establish "open account" status. You will find that providing a financial statement to a bank on an annual or more-frequent basis will make it easier for you to qualify for a line of credit when you do need it. Banks offer free consultation and advice on many financial matters.

Vendors

Your stock-house representative, frame salesperson, Eastman Kodak Company sales representative, and many others who may call on you possess mountains of knowledge from their own experiences in the photographic business. Don't hesitate to ask for their advice about anything having to do with running your business successfully. Most vendors will be very happy to answer your questions. I have found them to be quite professional, and their advice has been invaluable.

The Competition

Our major competitors are not other photographers. We are competing against billions of dollars invested in advertising of every product conceivable. This advertising is changing a "need" society into a "want" society. People don't need a Mercedes automobile, first class air reservations, or million-dollar homes. But they want them. Without a brand-name product, we have not spent enough dollars as photographers collectively to create enough "wants" to guarantee our successes.

The only adequate national and regional advertising in our industry is a result of the mass merchandisers. They are doing a great job of getting people, especially children, to be photographed at more frequent intervals than ever before. They are creating new business by encouraging people to spend money on photography. Some of these consumers will be using the services of the conventional studio operator rather than the mass merchandiser. Many consumers will be more interested in custom quality portraiture, the wider variety of product lines offered, and the more personal services that generally are available at the conventional studio. Despite the absence of advertising by individually-owned studios, mass merchandisers may be creating more business for us all.

We are trying to attract discretionary income—the same dollars being attracted by our real competition, the auto manufacturers and dealers, appliance manufacturers, travel agencies, airlines and steamship companies, restaurants, and sporting and theatrical events. All are at work to attract dollars that could have come to you. That's real competition.

Ways to personalize portraits abound. This background location perfectly complemented the subject and made for a more interesting image.

We are in the gift store business competing with others who serve the public's emotional needs. How many dollars do we lose each year to the candy, jewelry, and flower shops? It is difficult to read a newspaper before any holiday season without seeing advertisements presenting their products as the appropriate gift for Christmas, Valentine's Day, Mother's Day, Father's Day, or some sort of graduation. We have the most emotional, personal gift of all in our portraits. How sad it is to see how little we do to compete in the emotional gift forum. Doubly sad, because we have such an exciting product to offer.

We have the most emotional, personal gift of all in our portraits. How sad it is to see how little we do to compete in the emotional gift forum.

You will find that an investment in a well-planned, consistent, year-round advertising program can bring you greater market share, in addition to providing name-recognition benefits to all your marketing efforts.

I love photography! I love being in the business of photography. You share these feelings, don't you?

Wouldn't we all like to remain, progress, and prosper in this field that offers us joy, challenges, hard work, and so many intangible rewards? We can achieve success proportionate to our commitment and, in addition, enjoy community respect. We can't help making friends with people whom we might never have met had we not been in the photography business.

But here is a change coming in our future. The success of the minilab, fast-food franchises, one-hour optical services, and scores more indicate that convenience and speed are influencing buying decisions. Portrait studios haven't enjoyed a reputation for speed or convenience. This must change. To compete, we will need to shorten the interval between picture-taking and delivery.

The video and electronic imaging business is rapidly refining and improving the technology while lowering the price of the product. The alert, concerned photographer will keep abreast of this and determine how this technology can become a profit center rather than a threat to tomorrow's portrait photographer.

Color copy machines have become so sophisticated that we find it difficult to distinguish the copy from the original. While we enjoy the protection of the copyright laws, in a practical sense there will be rampant violations

Portrait studios must provide personalized styles, products, and services that mass merchandisers can not easily match.

that will adversely affect reprint orders in the portrait studio. What reaction will there be to this threat? Will the original photograph become more valuable to the consumer because of the ease of obtaining low cost copies? Will we, in the industry, successfully compete with the new technology? Will we be installing our own color copy machines? Anyone concerned with his or her future will address this problem and participate in neutralizing it or finding ways to capitalize from it.

Mass merchandisers are increasing market share every year. They are dominating the child photography market even while the independent studio is experiencing increased business in children's sittings. However, mass merchandisers are growing rapidly into new markets, especially in the elementary school and the high school and college senior markets. From these contracts, they are offering family photography. Their growth will come from creating new business and absorbing product lines previously sold exclusively by the independent studious. Through volume and organization, these vertically integrated companies will become a more influential force in the industry.

If we mistakenly look upon our competitors as unworthy and we appeal only to people of low taste and minimum budgets, we won't grow and prosper in today's competitive environment. If we recognize that our competitors are businesses selling their strengths while capturing a slice of the market, then we can react positively to protect and even expand our own markets. We may be able to exist side by side. Or, we may need to develop more customized styles and products and services not easily provided by mass merchandisers.

Seize the Opportunities

The challenges are great, but let's look at the bright side. In the century and a half since the invention of photography, today is the most opportune time of all in which to practice our craft!

We have so many things working for us—all the ingredients for success are present. We have the most affluent society of all time. We have more people with the means to buy our portraits than ever before. We have the technology and educational opportunities available to us to produce outstanding portraits. Through TV and magazine commercials, we have an educated public, most of whom can recognize creative and desirable photography. We have a product that can hold its own, being enjoyed on the walls of America's homes.

We have, however, a century of old photographs, many of which are in need of being copied, enlarged, restored, and hung as wall galleries in homes in our communities.

As each generation becomes more mobile, we are all becoming more appreciative of the family portrait. We no longer have the whole family together on the farm. We have people scattered throughout the world, and the family portrait at reunions becomes more precious to each of us.

In reviewing the talent, money, time, and education you must bring to you business, plus the planning, advisory, policy-making, hiring, training, and leadership skills you need to compete in the wonderful world of photography, one other attribute stands out as the most important of all. It is compassion. It best defines how you feel about your clients and your employees. Our business is a people business. If you lack compassion, you will be building your business on air. If you have compassion, you will have a firm foundation that will support all of the other qualities that will bring you success.

In presenting my game plan, I have provided a guide; it is by no means a comprehensive business text. Sound business practices and trends change, and you must keep up with them or fall behind your competition. Just as you will constantly seek to upgrade your photographic skills, so must you constantly upgrade your business knowledge. Good business skills and good photographic skills should be inseparable components of your portrait operation—one means little without the other. Together, they can lead the way to a successful future.

EQUIPMENT

BY JEFF WIGNALL

The equipment you will need to run a successful portraiture business will depend largely on the type of portraits you plan to make. If you intend mainly to photograph weddings and the occasional family or executive portrait on location, a pair of camera bodies, two or three lenses and a few portable flash units will meet most of your needs. If your ambition is to operate a full-service studio and location business, however, you're looking at a substantially larger (and more complicated) investment.

Whatever your plans, live by this rule when it comes to buying equipment: let spending follow need. It's easy to succumb to ads promising that more and better equipment equates to better photographs. But the truth is that most photographers are equipment addicts and own far more than they need. If you want to become a financially successful photographer (and not a camera collector), buy only the equipment that you need for your everyday work. When the occasional need arises for a special piece of equipment that you don't own, you can always rent it.

The flip side of this is, of course, that you can't let yourself become too cautious about buying new equipment. When you find yourself unable to make certain types of pictures because you lack a particular piece of gear, or when you lose confidence in the reliability of aging equipment, these are needs that should not be ignored. And, extravagant as it may sound, you should always have a backup for every piece of equipment that you own including camera bodies, lenses, flash units, battery packs, etc. What can fail will fail. And it will fail at the absolute worst moments.

From the outset, plan an annual equipment buying budget and regularly re-invest a certain percentage of your income in new hardware. The investment in quality equipment that you make today will increase both your photographic capabilities and profits tomorrow. You may also wish to speak to your accountant or a financial advisor about the possibility of long-term equipment leasing, particularly high-ticket items like studio lighting or large-format cameras.

Choosing a Camera Format

Which is the best format for portraiture? Again, the answer depends on your personal shooting style and the type of portraits you like to make. Traditionally, medium-format cameras using 120 and 220 roll film have dominated virtually all areas of portraiture because they offer convenience and a large negative size.

In recent years though, there has been a steady increase in the popularity of 35 mm cameras—due largely to technological improvements in professional film stocks. For example, KODAK Films that incorporate KODAK T-GRAIN® Emulsion technology make it possible to produce enlargements from 35 mm negatives that rival the quality of prints made from larger format negatives. Then too, some portrait photographers prefer the supreme image quality possible with large-format cameras and are willing to accept the more measured pace and extra expense.

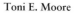

Toni E. Moore

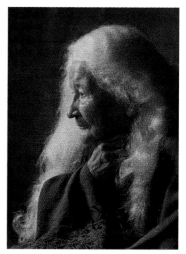

This sensitive portrayal was created on KODAK VERICOLOR III Professional Film.

Chances are by the time you decide to shoot portraits as a business, you will have already accumulated considerable equipment in a particular format. Eventually, your assignments will vary enough so that you will be working regularly in several different formats.

Shot on location late in the day, additional filtration added to the warm color of the sunset.

Patty Oakley

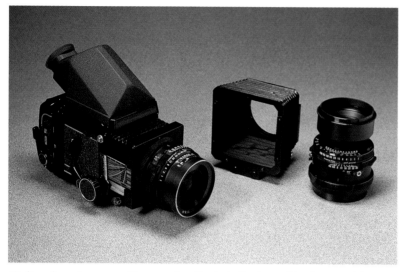

Medium-format cameras offer many benefits, including larger film size, portability, and a full range of lenses and accessories.

Here is a quick look at some advantages and drawbacks of each format.

Medium-Format Cameras

Regardless of the specific style or format, all medium-format cameras use either 120 or 220 film; both films are 2¼-inch width, but 220 film is twice as long as 120. The actual number of exposures you get will depend on the dimensions of the frame.

The primary advantage of working in a medium format is the larger film size. Medium-format cameras constitute a whole group of cameras that encompass a variety of negatives sizes, including 6 x 6 cm (2¼ x 2¼ inch), 6 x 4.5 cm, 6 x 7 cm and 6 x 9 cm. Even the smallest of these (6 x 4.5 cm format) provides a negative that's almost three times larger than a 35 mm negative; and the 6 x 6 cm negative is four times larger. Larger negatives generally mean bigger and better enlargements. Bigger prints fetch higher prices. Medium-format negatives can also be retouched which is not as easy to do with 35 mm negatives.

One of the first decisions you'll have to make in choosing a medium-format camera is whether you want to work with square or rectangular negatives (though several cameras have interchangeable backs that enable you to use both). A great many portrait photographers prefer square format 6 x 6 cm cameras. Their preference is based almost solely on aesthetics: they simply enjoy "seeing" in a square format.

There are some advantages to the rectangular formats; namely, you can compose either horizontally or vertically. You can also enlarge to standard paper sizes such as 8 x 10 and 16 x 20 inches without drastic cropping.

There are three styles of medium format from which to choose: SLR (single-lens-reflex), TLR (twin-lens reflex) and rangefinder. The most popular, by far, is the SLR design which, like a 35 mm SLR, lets you view your subjects directly through the "taking" lens. Unlike all 35 mm SLRs, however, not all medium-format SLRs have an "instant return" mirror: the viewfinder may black out until you advance the film and cock the shutter for the next shot. The nature of portrait work makes an instant return mirror a feature worth having.

Both rangefinder and TLR cameras enable constant viewing of your subject (no blackout, even during exposure) because you are viewing through a separate lens or viewfinder. In addition, since neither type has a reflex

If your style of portraiture is more journalistic and fast-moving in nature, the advantages of the 35 mm format are hard to ignore.

mirror, both are extremely quiet. The problem with these types of cameras though is that there are a limited number of lenses and other accessories available for them, limiting the use of rangefinder and TLR cameras.

35 mm Cameras

If your style of portraiture is more journalistic and fast-moving in nature, the advantages of the 35 mm format are hard to ignore. The light weight and compact size of a 35 mm SLR enables you to react quickly to your subjects' expressions and gestures. And you can bring more equipment with you on location. With its ease of use, a 35 mm SLR camera tends to put less of a technological barrier between the photographer and the subject. Most people have been photographed with an SLR before and the experience will not seem foreign to them.

Large-Format Cameras

David Ziser

Large-format or view cameras have long been favored by photographers who prefer a more formal style of portraiture. The two main sizes of large format cameras are 4 x 5 and 8 x 10 inches. Basically a view camera consists of a front standard that holds the lens, a rear standard with a film holder and a flexible bellows in between. This arrangement means that you can move the film and lens planes entirely independently of each other. This ability to move the film and lens planes independently gives you enormous flexibility in both composition and perspective control. In photographing a group portrait outdoors, for example, it's possible to shift the lens to the left or the right to exclude a distracting tree limb without having to move your camera.

Negatives produced by a large-format camera have a sharpness and clarity that no other format can equal. If your studio is in an urban or upscale suburban market, the demands of a more affluent clientele may justify your use of a large-format camera. The superb quality of the very large print sizes obtainable from a large negative can be an excellent selling point for your studio. While few portrait photographers work in large-format, those who do may fill a niche that is overlooked by their competitors.

Architectural elements combine with an unusual viewpoint to create this dramatic environmental portrait.

Working Distances

Film Size	Type of Portrait	Suggested Focal Length*	Minimum Working Space † (In feet)
35 mm	Head and Shoulders	75 mm	16
	Full-Length Figure	50 mm	17
	Groups 10 Feet Wide	35 mm	17
2¼ x 2¼ (6 x 6 cm)	Head and Shoulders	120 mm	16
	Full-Length Figure	80 mm	18
	Groups 10 Feet Wide	50 mm	19
2¼ x 2¾ (6 x 7 cm)	Head and Shoulders	135 mm	16
	Full-Length Figure	90 mm	15
	Groups 10 Feet Wide	60 mm	18
4 x 5 inches	Head and Shoulders	8½ to 10 inches	15
	Full-Length Figure	6 inches	16
	Groups 10 Feet Wide	100 mm (wide field)	18
5 x 7 inches	Head and Shoulders	12 to 14 inches	15
	Full-Length Figure	8 to 8½ inches	15
	Groups 10 Feet Wide	135 mm (wide field)	16
8 x 10 inches	Head and Shoulders	14 to 16 inches	15
	Full-Length Figure	12 inches	17
	Groups 10 Feet Wide	190 mm (wide field)	18

** Not using camera swings.*
† These values assume the image occupies 90 percent of the negative dimension and includes an allowance of about 7 feet for lights, background, and camera working room.

Lenses for Portrait Photography

The camera format you're working in will dictate the lens focal length you'll want to use in different portrait situations. Specific camera and lens combinations also determine the minimum working space you'll need (see the accompanying table). Lenses are commonly grouped into three broad categories according to their focal length (normal, wide-angle, and telephoto). There are some general guidelines for these groupings that will help you decide which lens type is right for a given subject.

Wide-Angle Lenses

Wide-angle lenses are excellent for group or full-length figure shots, especially where shooting distance is limited. Wide-angle lenses can also help to give a

Most individual portraits and couple shots are made with moderate telephoto lenses. The perspective created by these lenses has a pleasing look.

"thinner" appearance to some faces when used for individual portraits. Beware though of working too close thereby causing facial distortion. In some settings, however, the short working distance and elongated perspective can be useful, for example, exaggerating the size of an executive office or board room.

Normal Lenses

Normal lenses record subjects much the same way as our eyes see them. When you have the shooting distance available, using a normal lens for group portraits will prevent distortion at the edges of the frame.

Medium Telephoto

Most individual portraits and couple shots are made with moderate telephoto lenses. The perspective created by these lenses has a pleasing look. Longer lenses also enable you to limit depth of field to create selective focus effects. In addition, telephoto lenses let you work farther from your subject so that your presence is not so imposing and so that you don't inadvertently shadow your subject.

Instant Proofing—The KODAK PRISM Electronic Previewing System

The sooner you show your clients the proofs from their portrait sessions, the more excited they will be about ordering prints. And perhaps the fastest way to show them proofs is with the KODAK PRISM Electronic Previewing System. This system simultaneously records a film image and an electronic image. This means that you can show your clients instant video proofs.

The PRISM Electronic Previewing System consists of two easy-to-operate stations, one in the camera room and the other in the sales area. In the camera room, you can compose a subject in the viewfinder and see it in real time on a television monitor. With the option of capturing and viewing just the electronic image, you can work with your subject to select the most preferable poses before you commit an image to film.

When you trip the shutter to actually take the picture, you also save it on a 2 x 2-inch still video disk. The disk has a storage capacity of 25 poses, so you can match a full roll of 220 medium-format or 24 exposure 35 mm film to a single disk.

John Myers

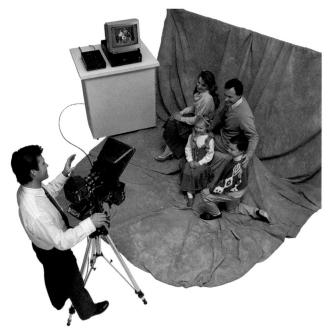

The KODAK PRISM XLC Electronic Previewing System provides instant video feedback to check the lighting, pose, and expression.

Gary Whelpley

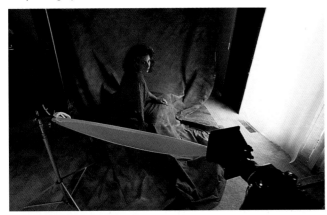

Portable reflectors for studio or location work come in many styles, shapes, and colors.

Gary Whelpley

Fill light from the reflector opened the shadows on the left side of the subject's face.

After a shooting session, you and your client can review the recorded images in the sales room of your studio. The selling station part of the Prism system includes a still-video playback unit, to which you add your own color monitor. You can also add an optional color video printer so that your customers can get instant hard-copy proofs of their chosen poses.

The PRISM System is compatible with whatever 35 mm, medium-format or long-roll film camera (and lenses) that you're already using. Compact enough to take along on location, the Prism system packs into just a few cases and can be set up quickly in a home, office, and school.

Lighting Equipment

Electronic Flash

The primary type of lighting used in portrait studios is electronic flash. Flash has three major advantages: it's extremely powerful, it produces almost no noticeable heat and it is balanced for daylight films. Also, the short duration of a flash exposure is good at stopping motion, which is helpful in glamour or fashion portraits where you may want the models to swirl or twirl, but you don't want them to appear blurred in the picture. One disadvantage of flash is that you have to judge your lighting effects from the relatively dim light of the modeling lamps.

Though there are many brands and models of studio flash from which to choose, they are divided into two broad categories: modular power packs in which a single power supply provides power to a number of different flash heads and monolights in which the power source and light head are housed in a single self-contained unit.

Power Packs: In this type of system, each of the heads is connected to a central power supply by a cable. The camera must also be connected to the pack (via a PC cord) so that the flash heads will fire when you press the shutter release. Alternatively, some power packs work with an infrared transmitter that attaches to the camera. The advantage of a remote triggering system is obvious: it lets you move about the studio without being tied to (or tripping over) a PC cord.

Flash power packs are available in a wide variety of power outputs, ranging from a few hundred to several thousand watt/seconds. If you plan on working with two or more heads from a single pack, you will probably need a power supply that produces somewhere between 400 and 2000 watt-seconds. Anything less powerful won't produce the power you need, particularly if you're diffusing the light or working with large-format cameras; more power is always nice, but increases in power do not come cheaply.

Perhaps the greatest advantage of using a power-pack flash system is the versatility with which you can adjust the power that each one of the flash heads is getting. In turn, you can alter the lighting ratios or manipulate lighting effects. Most power packs offer a choice of either "symmetrical" (each head gets the same amount of flash power) or "asymmetrical" (each head can be given a different amount of flash power) power distribution. Many offer a choice of distribution modes. The benefit of using an asymmetrical arrangement is that you can adjust the lighting intensity of each head individually. This enables you to maintain a constant amount of light to a given head (by turning the power up or

down), even if you change the light-to-subject distance, or if you add or subtract filtration, diffusion, etc. For even greater control, many packs also offer a feature called a "power variator" that enables you to adjust the total output of power to all heads simultaneously while maintaining the exact distribution.

The chief drawback of a power pack system is the lack of portability for location work. Even if you know you're only going to need one flash head, you must still bring along the power pack and cables. Also, many packs have higher voltage requirements and cannot be safely plugged into just any electrical outlet, so for example, you may not be able to use your pack for a family portrait on location using household current.

Monolights: Nearly anything that can be done with a power pack and heads can also be done with several monolights. The only difference is that you have to

Most monolights are comparatively inexpensive. You can buy one light to start and then add additional lights as you need or can afford them.

adjust each light individually. If you get to the point of using three or four lights in your lighting set-ups, carrying that many monolights will be a heavier proposition than bringing one pack and several flash heads.

Most monolights are comparatively inexpensive. You can buy one light to start and then add additional lights as you need or can afford them. Also, since they aren't connected to a central power pack, monolights can be placed anywhere on a set and at any distance from one another: if you have an outlet (or an extension cord), you can put the light anywhere at all. And virtually all monolights are safe for plugging into a household or office outlets, which enhances their location appeal.

Finally, if you are using monolights and one light burns out, you still have the others. If a power pack fails, it is unlikely that you will have a backup power pack.

Accessories for Electronic Flash

Most flash heads come standard with a polished parabolic reflector, which creates very intense, but high-contrast lighting which is not particularly flattering for portraits. A number of different types of light-modifiers

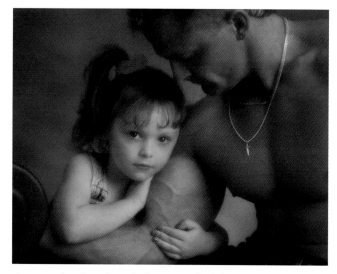

An unusual and touching dual portrait of a father and daughter.

can be used to soften this light, including umbrellas, softboxes, and fabric frames.

Umbrellas are available in reflective and shoot through varieties. Reflective umbrellas, in which the light is aimed into the umbrellas and away from the subject, are used to spread and soften the light. Shoot-through umbrellas, in which the light is aimed at the subject through the fabric of the umbrella, creates a similar, but slightly more directional lighting with a central "hot" spot.

Soft boxes are available in a wide-range of sizes and shapes to create the softest lighting effects. Some let you aim the head through the front diffusion panel directly or bounce off of an interior reflective surface.

Fabric frames are collapsible plastic frame and fabric panel sets which are popular and versatile. One frame can be covered with a variety of interchangeable fabrics for reflecting, absorbing, or diffusing light.

Hot Lights

Continuous-source artificial light or "hot" lights use either tungsten or quartz-halogen type lamps and have color temperature of 3200-degrees K, which means you either have to use a tungsten-balanced film or filter up to a daylight color temperature (at the expense of about one stop in light output). Tungsten lamps and fixtures are available in a variety of powers, with the most popular being 500, 750, 1000 and 2000 watts.

One nice aspect of using hot lights is that what you see is what you get. Because you're viewing your subject under full light, you are less likely to find any lighting surprises in the final image. Also, since there

is no sudden burst of light, your models won't blink or flinch as many people do with flash. A single hot light when combined with flash is also useful for a pleasing creative effect. For example, you may wish to create a warm fill or edge light.

The chief disadvantage of hot lights is that...well, they are hot. In order to get the amount of light you need to light a portrait (particularly a group portrait), you will need several lamps. These many lights will have your models wilting and the brightness may cause them to squint.

Accessories for Hot Lights
Several companies make soft boxes and umbrellas that are safe for use with hot lights. But because of the heat produced by hot lights, most of the light-modifying devices used with strobes cannot be safely used. Be certain that you're using diffusion materials intended for use with hot lights.

On Location
For a lot of location work, one or more portable flash units will provide all the lighting power that you need. There are basically two types of portable strobes available: automatic flash and dedicated flash units. *Automatic flash units* use a flash-mounted light sensor to control the flash output. *Dedicated flash units* share exposure information with compatible cameras, and flash output is monitored and controlled from the film plane by the camera's electronics. Dedicated flash systems are very accurate. In choosing a portable unit, here are some features to consider:

Power: The more, the better. Choose a unit with a guide number of about 110 or higher. Lower power units will provide enough power for direct-flash photos, but very often you'll be bouncing or diffusing the flash which uses up light.

Power Selection: The ability to adjust the output of the flash makes it much more versatile. In fill-in flash shots, especially, you will want the ability to turn down the power of the flash.

Aperture Selection: Pick a unit that offers a choice of at least four automatic apertures so that you can control depth of field.

Gerri Karamesinis

A texture screen and slight overexposure added just the right touch to this dreamlike summer scene.

Tilt and Swivel: The ability to tilt and swivel your flash simultaneously means that you can bounce the flash off of a reflector or wall whether you're shooting a horizontal or vertical composition.

Filters
Filters come in an array of styles and a rainbow of colors to perform all manner of technical and creative tasks. The three basic styles of filters are gelatin squares, glass or resin drop-in filters, and glass screw-in filters.

Gelatin Squares
KODAK WRATTEN Filters are sold in gelatin squares in a wide variety of styles, including color correction, neutral density, color conversion, etc. These filters are designed for use in individual filter frames that attach to the lens with a filter-frame holder. Wratten filters have a uniform thickness of about 0.1mm and provide superb optical quality.

Glass or Resin Drop-in Filters
These filters are typically sold in either three- or four-inch squares and are designed for a special filter holder that attaches to the front of the lens or onto a "compendium-style" lens shades (see photo). The best quality filters are those made of either optical glass or optical resin.

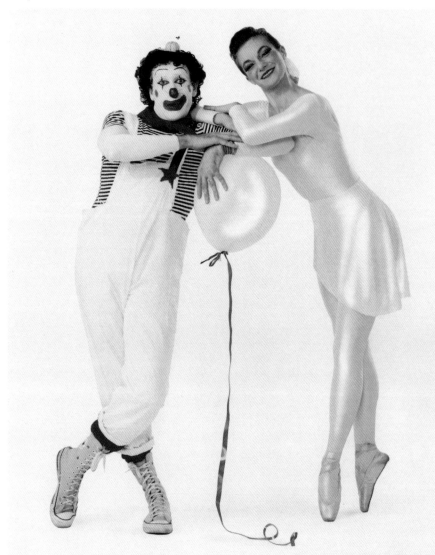

While the variety of background materials is almost limitless, plain white seamless provided the ideal treatment for this whimsical high-key image.

dimples, and etched surfaces. Each of these styles is usually also available in a variety of intensities. The only way to know which filters work for you is to try several brands and styles.

Light Balancing: One of the technical challenges of outdoor portraiture is that the color of sunlight isn't constant; it can change with the weather and the time of day. The best way to cope with these changes is by using light-balancing filters. There are two series of light-balancing filters. The 81 series are yellowish in color and are designed to warm up colors by lowering the color temperature of cool daylight (with daylight films). The 82 series filters are bluish in color and are designed to raise the color temperature of existing light.

Backgrounds

Painted muslin, splattered canvas, metalized fabrics, seamless paper, rear projected scenes—if there's one thing there is no shortage of in portraiture, it is a choice of creative background materials. And the backgrounds that you use can have a powerful influence on the mood and impact of your portraits. The color, texture, and style of the background are all factors that must be matched to your subject.

Seamless Paper

This is the most basic of photographic backgrounds and it comes in an wide variety of solid colors. It makes an excellent choice when you need a plain background to color the scene, without distracting from the subject. One of the nice qualities about seamless is that when the background gets dirty or crinkled from use, you can simply unroll a fresh supply and cut away the old.

Glass Screw-in Filters

These filters thread onto the front of the lens. They are very rugged and good ones have excellent optical qualities. However, if your lenses have different front diameters, you have to buy duplicate filters or adapters to fit those different lenses.

Filters for Portraits

For most portrait situations, the two groups of filters that you will probably use on a frequent basis are soft focus and light balancing filters.

Soft Focus: There are dozens of different styles of soft focus filters on the market. Manufacturers use all sorts of optical tricks to create their diffusion effects including frosted plastic, black or white netting, glass

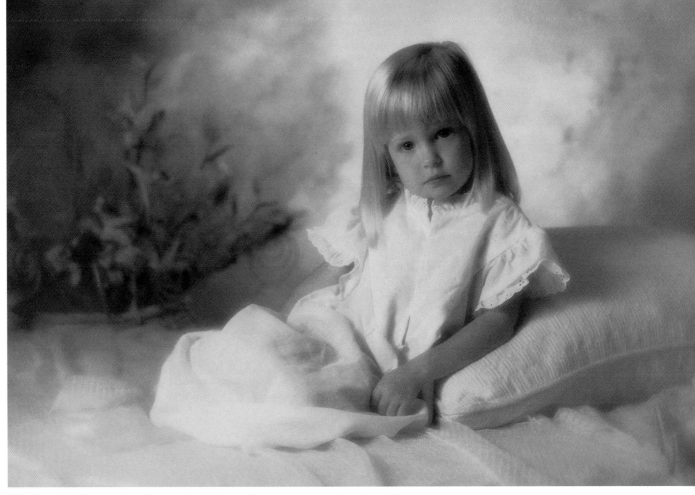

Selecting the right props is vital to creating the desired mood and feeling. The studio even supplied the white outfit for this tender portrait.

Doug Hoffman

Muslin and Canvas

These are the most popular portrait backgrounds in use today. They are typically either painted or dyed and feature an eclectic array of patterns, ranging from a "marbleized" look to "streaked" and "splattered"

The backgrounds that you use can have a powerful influence on the mood and impact of your portraits.

designs. Both muslin and canvas backgrounds are sold in hand-painted and mass-produced versions (and are priced accordingly). Many companies also give you the option of special-ordering a particular blend of colors, or specifying a certain design.

Muslin is a much lighter fabric than canvas. One of its main advantages is that it can be "covered" or "shaped" to fit around props or models. Canvas backgrounds are considerably stiffer and are designed primarily for creating vertical or evenly sloped backgrounds. If most of your portraits are done on location, muslin makes a better choice because its light weight means you can roll it up and pack it in a carry sack.

Projection

Still another type of background system that is used successfully by portrait photographers is front or rear projection. Projection systems allow you to project an almost infinite variety of scenic backgrounds or other images behind your subject.

A softbox provided the main light with a reflector for fill. A red gel added impact and reinforced the red hot color scheme.

© Fernando Blanco

Light Meters

Whether you use daylight, tungsten or electronic flash to light your portraits, you must have a way to measure the amount of light you are using if you hope to get consistently accurate exposures. And though the built-in meters for most 35 mm and medium-format cameras are very sophisticated, there are many functions, such as measuring studio flash, that only a handheld meter can perform.

Light meters measure reflected light or incident light. Some meters are able to make only one type of reading, but many can take both measurements.

Reflected-light meters measure the amount of light that is reflecting back from your subject. Readings made with a reflected-light meter are normally made

from the camera position, because it is important that you measure the same reflected light that the camera will see. One important factor to consider with a reflectance-type meter is its angle of acceptance, that is the angle of light that the meter is measuring. Typically this angle is about 30 degrees, but some meters have diffusion domes atop the measuring receptor and take in a much broader 180-degree angle of light. While either reading may be fine for taking an approximate reading, it is not particularly accurate or selective. A more discriminating method is to use a meter that provides a smaller angle of view. *Spot meters* (or a spot attachment) provide the ultimate in detailed readings, often measuring only a single degree of image area.

Incident meters are particularly useful for determining lighting ratios.

Overall, a better way to measure light in most portrait situations is to use an *incident meter*. These meters measure the amount of light that is falling on your subject. Readings are usually taken by holding the meter at the subject position and aiming it either at the main light source or at the camera (depending on the type of lighting you are using). Incident readings are more dependable because they are not affected by extraneous reflections that may fool a reflected meter.

Overall, a better way to measure light in most portrait situations is to use an incident meter. These meters measure the amount of light that is falling on your subject.

Meters are also defined by the type of light they measure. Those that measure only existing light are called ambient light meters. These meters can be used to measure any type of continuous light source, including daylight, tungsten, and fluorescent. There are also flash meters and color temperature meters.

Flash meters are designed specifically for measuring electronic flash. The more sophisticated models can measure both ambient light and flash, either separately or simultaneously. Some even show you the ratio between the two types of light. Flash meters are invaluable for accurately and easily determining exposure for multiflash setups or for multiple exposures, and some units have a memory feature for retaining (and averaging) several readings. A versatile flash meter minimizes or eliminates the guess work of using additional lights, umbrellas, reflectors, and softboxes. When you require a specific aperture to control depth of field, a flash meter can tell you how to adjust the output of your lights to achieve it.

Color temperature meters are used to measure the exact color temperature of either existing light or flash, or both. With most color meters, you first enter in the color temperature that the film you are using is balanced for (e.g. 5500K for daylight films). You then take a reading by aiming the meter from the subject to the main light source. The meter will tell you the actual color temperature of the flash or existing light. Most meters will also provide the necessary corrective filtration information.

Elma Garcia

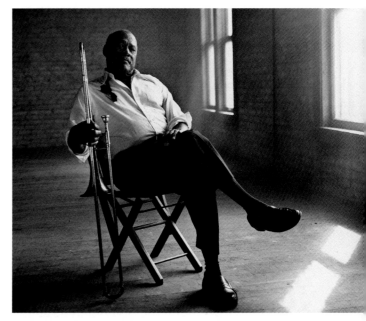

The simple props and setting combined with natural window light to create this arresting monochrome portrait.

EXPOSURE AND LIGHTING TECHNIQUES

BY FRANK CRICCHIO

A quality photographic portrait is the sum of many factors. Lighting, composition, equipment, posing, artistic talent, and technical excellence must all come together to produce professional results. Art and technique should combine in a way that is invisible to the subject.

The more you know about the tools and photographic materials you use, the greater will be your ability to create the pictorial quality you want. No matter how imaginative or delicate your portrait lighting may be, it will not carry over into the print unless you understand the key factors which influence quality. The following six steps are vital to creating top-quality images when using color negative film:

1. *Select the appropriate equipment for the desired lighting effects.*
2. *Determine the main, fill, and background light intensities for a desired lighting ratio.*
3. *Establish a working exposure index (film speed) for your standard lighting condition.*
4. *Determine exposure indexes for other lighting conditions.*
5. *Modify your lighting techniques, as needed, for consistent, professional portrait results.*
6. *Establish appropriate lighting techniques for portraiture.*

Step 1: Select the Equipment

The lighting equipment you select will determine the quality of your photographs. You will need a fill light, a main light, a background light, and a hair light. Always keep the contrast of the photographic light in mind when selecting lighting equipment. Diffused reflectors, umbrellas, and bounce lights are considered low-contrast, soft-light sources because they produce a soft shadow edge of the subject's features. Spots and parabolics are considered hard-light sources. The hard-light sources produce a more defined shadow edge, giving more shape to the subject's features than low-contrast, diffused light sources.

Fill Light

The fill light illuminates the shadows of a photographic subject and is the only light that photographically registers the shadows on film. It also raises the illumination level in all areas of the subject.

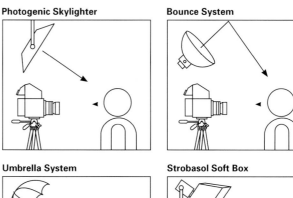
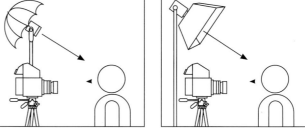

These are some of the popular equipment options that are available when you require a low-contrast light source.

The fill light pattern should be soft and expansive in nature and should create an even wall of light at the photographic plane. It should illuminate a single subject evenly from head to toe and be wide enough to cover a large group completely.

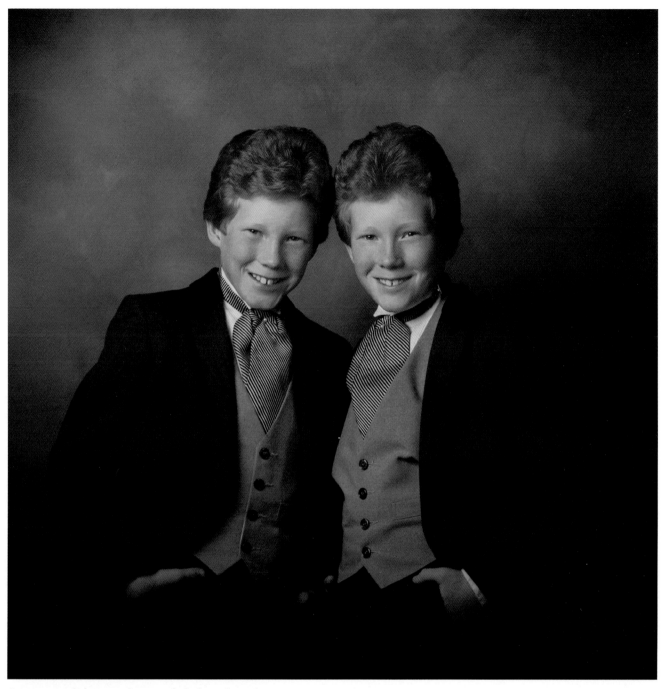

Low-contrast lighting produces a soft shadow edge and creates a gentler mood.

David Ziser

The fill light should not be evident in the final photograph; therefore, it should be a low-contrast light source, as nonspecular and nondirectional as possible.

Main Light

The main light has two functions, one mechanical and one aesthetic: Its mechanical function is to establish the contrast quality of the light and the lighting ratio. Its aesthetic function is to illuminate the subject's eyes and to shape the face to its best likeness.

The main light should be a directional light source that produces more contrast than the fill light. It determines the mood of the photograph by its contrast quality. The higher the contrast, the stronger the statement about the subject's features. The lower the contrast, the softer the statement and gentler the mood portrayed.

Feathering the Main Light: Photography "masters" prefer main-light reflectors designed to create a light pattern that is brighter in the center with light gradually falling off in intensity toward the edges. This quality enables the photographer to adjust the light by "feathering," which is the technique of using the "penumbra" of the light source to achieve even illumination across the facial plane with soft specular highlights. The

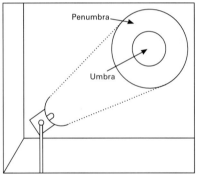

Parabolic Reflector

The penumbra, the soft edge of the circular light pattern, allows you to feather the main light.

photographer strives for good gradation of tones and smoothness between the highlights and shadows of the subject's features.

Feathering cannot be achieved with the principal light source aimed straight at the subject's face. This would illuminate the face with the brighter center spot (the "umbra") of the main light pattern. The effect is achieved with the soft, feathered portion of the main light pattern (the "penumbra"), also referred to as the edge of the light.

To find the correct placement of the pattern of light so that the face is properly illuminated, move the main light pattern up and down until the intensity of light on the forehead and chin are the same. The intensity of light must also be the same in the highlights on the shadowed side of the face and on the cheeks. Do this by swinging the reflector from side to side until specular highlights can be seen and the five planes of the face are illuminated evenly.

When properly positioned, the main light should produce the desired scene contrast from shadow to highlight without the need for "barn doors," "scrims," or "gobos." In portraiture, the main light should act as

The higher the contrast, the stronger the statement about the subject's features. The lower the contrast, the softer the statement and gentler the mood portrayed.

a modeling light to project the specular highlights, gradating the tones from specular to diffused to subtly illuminated shadows. Barn doors or diffusers are not recommended on the main light. Barn doors diminish the feathered edge of the light pattern, and diffusers change the quality of the modeling light into a broad flood light.

Guide Point: *To achieve the "masters touch" of feathering light, the main light should produce a circular pattern that is brighter at the center and gradually falls off toward the edge. At two feet from the umbra (the bright center of the pattern), the light should be a half-stop less in intensity.*

Illuminating the Five Planes of the Face: The position of the main light determines the aesthetic effect of the light on the subject. Once you position the main light at the necessary distance, you can adjust it to render the desired aesthetic effects. The highlights created by the main light should illuminate the five planes of the face (forehead, left and right cheeks, nose, and chin), defining the facial contours and creating the effect of dimension.

Illuminating the Eyes: To light the eyes properly, lower the main light until a specular highlight is reflected in the subject's eyes, then continue to lower it until you illuminate the color of the eyes. When the main light is adjusted properly, the eyes will have highlights and a crystalline appearance and the coloring will be clearly visible.

Illuminating the Nose: The main light also shapes the subject's nose. Position the light so that a nose shadow is cast onto the shadow side of the face. When the shadow is smooth in tone, the light is in the right position. To check this, move the main light until the shadow of the bridge of the nose just touches the white of the eye on the shadow side of the face. Stop at this precise point. If the shadow from the bridge of the nose moves into the white of the eye, the eye will become dull and begin to appear smaller.

Guide Point: *If the subject has one eye that is larger than the other, you can take advantage of this phenomenon by placing the shadow from the bridge of the nose into the white of the larger eye.*

Main-Light Patterns

You can position the main light to create four distinct lighting patterns for portraiture.

Butterfly: The principal light is pointed down at a 45-degree angle directly into the frontal plane of the face. This type of lighting is used to enhance the glamour of a subject with high cheekbones and a beautiful face.

Open Loop: The principal light is pointed down at a 45-degree angle and off to the side of the nose, forming a loop-type shadow from the nose. This type of lighting brings out brilliance in the coloring of the eyes more successfully than closed-loop lighting.

Closed Loop: This type of lighting is also known as short, Rembrandt, or triangle lighting. It is normally used with low-key lighting. The principal light is

Frank Cricchio

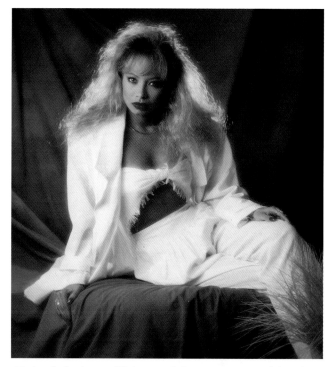

Aiming the background light toward the camera separated the subject from the background, enhancing the sense of depth and dimension.

pointed down at a 45-degree angle and 45 degrees to one side of the face, with the shadow side of the face toward the camera.

Broad Lighting: This style of lighting alters the facial features the least and does the least amount of correction. Broad lighting places three quarters of the face in highlights. A low-contrast, broad main-light source works best for this type of lighting. Broad lighting is normally used with high-key lighting setups.

When in doubt, use either closed- or open-loop lighting. They are the most effective lighting techniques for giving texture and depth to the photograph.

Guide Point: *When using open- and closed-loop lighting, both sides of the nose should not be illuminated. The side of the nose nearest the camera should be completely shadowed. The shadow from the bridge of the nose cast into the eye determines whether you use open- or closed-loop lighting. The main light should not cast a shadow of the bridge of the nose into the opposite eye.*

Background Light

The background light, like the main light, has an aesthetic function. It separates the subject from the background to keep the subject from appearing as a cutout image pasted onto the background. When the background light is positioned correctly, the result

David Ziser

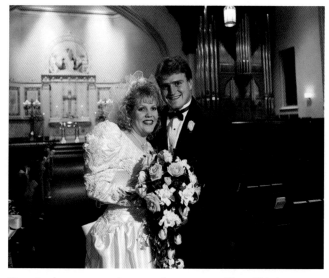

Knowing how to properly rate and expose your film will help you achieve the optimum negative under every type of condition.

31

Frank Cricchio

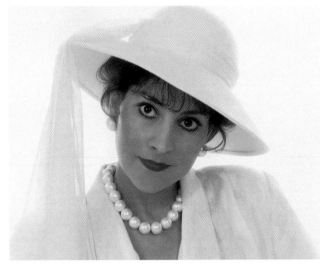

In this high-key portrait, strong background lighting provided maximum separation for the subject. The low-contrast main-light softly illuminated the face.

should be a soft glow of background illumination appearing between the subject's ears and shoulders, thereby achieving an effect of dimension. Dimension can also be created by aiming the background light toward the camera from behind the subject to rim the subject completely with highlights.

Guide Point: *The glow should not show above the subject's head or down around the waist. It should be brighter on the main-light side than on the shadow side of the subject. The result will be a light trap (a glow completely surrounded by shadows), which is undesirable by today's photographic standards. If any glow shows on the shadow side, try to minimize it.*

Hair Light

The hair light should be a glow of light that matches the main light in contrast quality. It should produce the appearance that it is a continuation of light from the same direction as the main light, giving highlight and detail to the hair. You can use a low-watt second main light instead of the usual spot-type hair light to pick up and illuminate the hair on the shadow side.

The effect of the hair light should be a soft glow and not an attention-getting type of light. The eye will always be drawn to a bright highlight surrounded by shadow because it is a high-contrast area. The brightest area of a photograph will not always pull the eye to that spot because it is possible to have a large, bright area without high contrast. Keep this in mind when you place your hair light. Remember, a hair light should not call attention to itself in classical portraiture.

Step 2: Determine the Correct Exposure

Maintaining consistent illumination and light placement are essential in establishing the correct color-negative exposure. The following procedure for establishing correct exposure is based on using KODAK VERICOLOR III Professional Film (VPS). You can adapt this procedure to other color negative films as well.

In the following density tests, you will photograph the KODAK Gray Scale next to your subject's head and use the 1.90 reflective reference patch on the scale to measure shadow density. The 1.90 reflective reference patch represents the blackest black that will have detail in the final photograph.

Maintaining consistent illumination and light placement are essential in establishing the correct color-negative exposure.

You will achieve the correct density aim points by first getting a D-min (minimum density) reading of a clear piece of processed film. You are actually reading

Frank Cricchio

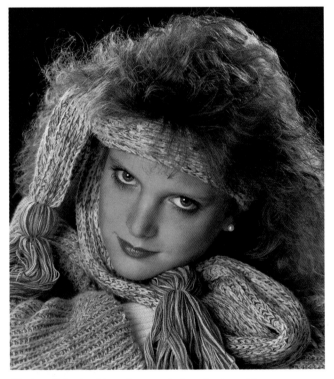

The hair light should produce a soft glow that just picks up and illuminates the hair on the shadow side where the main light leaves off.

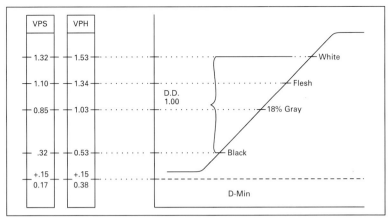

Density aim points for Kodak Vericolor III (VPS) and Vericolor 400 (VPH) Film are indicated on the H & D curve for a full-range print.

the density of the orange-magenta printing mask of the film. This requires a color transmission densitometer set on the Status M red filter setting. If you don't have a densitometer, your local professional color lab should be able to help you.

The D-min reading of processed VERICOLOR III Film will run from approximately 0.12 to 0.20 density units. Your goal during these tests is to produce a shadow density of 0.10 to 0.20 units above the film-base D-min for a total density of 0.22 to 0.38 (or 0.30 plus or minus 0.08 units).

Guide Point: *The purpose of determining the main-light and fill-light intensities is to establish a lighting ratio that gives you a density difference of 1.00 from black with texture to white with texture. This will enable all detail in your negative image to be recorded when the image is printed on photographic paper.*

Fill-Light Density Test

Use only the fill light in this test. A soft, nondirectional, nonspecular, nonevident type of light source such as one 800-watt-second Photogenic Skylighter or the

equivalent in umbrella, softbox, or bounce light(s) is recommended.

The bottom edge of the fill light should be 6 feet from the floor and 12 feet from the subject. The subject should be seated 6 to 9 feet in front of the background and the camera should be moved in and focused for a tight close-up. Ask your subject to hold a KODAK Gray Scale and a KODAK Gray Card (18% reflectance) angled slightly to avoid picking up reflections. The black square on the scale should have an image on the negative of at least ¼-inch across to enable an accurate reading on a transmission densitometer.

Beginning at *f*/5.6, make a series of exposures at each half *f*-stop. An information card indicating the *f*-stop used in each exposure should be included in the picture area. Have the film processed and make densitometer readings of the densities of the 18% gray card and the

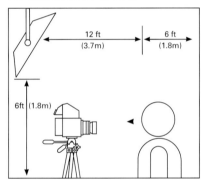

The setup for the fill-light test.

black square on the scale (the lightest square on the negative) before making the second test. The exposure that gives you a Status "M" red filter transmission density of 0.30 unit from the black square on the gray scale is the *f*-stop you should use to make your main-light test photographs. This correlates with a density of 0.65 from the gray card. With these readings, you should have enough density to see detail in the shadows of your image.

Fill-Light Density Test

Distance ft (m)	Intensity (watt seconds)	Lens Setting	Black Density	18% Gray Density	Flesh Density (Diffused Highlight)
12 (3.7)	800	*f*/5.6	0.52	0.93	1.15
12 (3.7)	800	*f*/8	0.37	0.74	1.00
12 (3.7)	800	*f*/11	0.30	0.65	0.88
12 (3.7)	800	*f*/16	0.16	0.48	0.64
12 (3.7)	800	*f*/22	0.15	0.37	0.53

Guide Point: *The gray-card density in the fill-light test is only 0.65. The gray-card density with illumination from both the main light and the fill light will read 0.85. It is important to remember that when set correctly, exposure meters will read exposures to give an 0.85 gray-card density. Therefore, do not use a procedure that meters only the fill light for your exposure.*

In some situations, you may prefer to work with a larger or smaller f-stop. You can then achieve the same results by increasing or decreasing the intensity of the fill light(s). If you double the fill-light intensity to 1,600 watt-seconds, close the lens aperture by one full f-stop. If you halve the fill light to 400 watt-seconds, open the lens by one full f-stop. Be sure to test this method before you attempt to make a photograph.

Main-Light Density Test

After adding the main light, the scene brightness point to strive for (aim point) should be a difference of 1.00 unit of density from highlight to shadow. The density difference should never exceed 1.00 unit, which is the contrast range limit of color paper. This 1.00 unit of density difference represents the difference between the previously determined fill-light shadow density of 0.30 and a soft diffused-highlight density of 1.30 produced on the white references of the step scale by both the main light and the fill light. While a white card would probably register as high as 1.90 density units on the negative, remember that when color negative density values go below 0.30 or above 1.30, exceeding a density difference of greater than 1.00, this detail will not be recorded on color paper.

In the main-light test, your lights should be set up exactly as they will be for making portraits. If the main light is feathered in the test, it should be feathered when making portraits.

For a head and shoulders test of an average subject with medium skin tones, place the subject 6 feet from the background. Keep the 800 watt-second fill light in the same position as in the fill-light test. Ask your subject to hold the gray scale and gray card. Use the same f-stop that rendered the 0.30 unit reading of

shadow density during the fill-light test. Again include an information card in each exposure, noting the light units used, the power setting, and the distance from the main-light flash tube to the subject's chin.

Before making the test, be sure that the inside of the reflector is clean and free of dust, dirt, and grime by wiping it with a clean cloth. If your main light is a Photogenic Studio Master II unit, place it so the flash is in a feathered position 45 inches from the subject's chin. This will model the subject's face properly. Make test exposures at 25, 50, 100, and 200 watt-seconds.

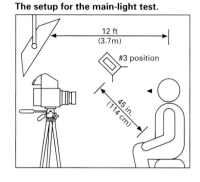
The setup for the main-light test.

12 ft (3.7m) / #3 position / 45 in. (114 cm)

If your main light has a fixed output, you may adjust its intensity by moving it back to various predetermined distances. The distances should be 35, 45, 63, 95, and 125 inches. The idea is to reduce the intensity of the light by half each time you move the unit. If your equipment is not efficient at these suggested distances, make your first test at the distance at which your light functions best. Then multiply this distance by 1.4 to find the next distance to position your main light in order to cut your light intensity in half. For example, if your first test is at 10 feet, your next test would be at 14 feet (10 feet x 1.4), and the third test would be at 19.6 feet (14 feet x 1.4).

Note: This system does not work for expansive light-source equipment such as umbrellas.

In the main-light test, your lights should be set up exactly as they will be for making portraits. If the main light is feathered in the test, it should be feathered when making portraits.

When you have your test roll of film processed, ask the lab to read and record the following densities for each exposure:

- *Diffused highlight of the flesh.*
- *The white references step.*
- *18% gray-card references.*

Main-Light Density Test

Fill Light		Main Light				
Distance ft (m)	Intensity (watt seconds)	Distance in (cm)	Intensity (watt seconds)	Lens Setting	White Density (Diffused Highlight)	18% Gray Density
12 (3.7)	800	45 (114)	25	f/11	1.23	0.74
12 (3.7)	800	45 (114)	50	f/11	1.30	0.85
12 (3.7)	800	45 (114)	100	f/11	1.45	0.98
12 (3.7)	800	45 (114)	200	f/11	1.63	1.10

This will tell you which of the main-light intensity settings or distances register a diffused flesh highlight density of 1.10 on the subject's forehead. The gray side of the KODAK Gray Card that receives the same illumination as the subject should read 0.85 density. The white references step should read 1.30.

When the 0.30 shadow density in the fill-light test is subtracted from the 1.30 diffused highlight density of the main-light test, the remaining 1.00 density difference is the scene brightness. This density difference can now produce color negatives that will print with full detail in both the shadow and highlight ends of the exposure scale. The 1.00-unit density difference between highlights and shadows assures that the negative matches the color-paper scale which, as noted previously, can handle a 1.00-unit density spread.

Guide Point: *This 1.00-unit density difference is achieved with a 4:1 lighting ratio. In a 4:1 lighting ratio, with a fixed fill light behind the camera, the main light is 1½ stops brighter than the fill light. If you want or need less density in the highlight areas of the print, the lighting ratio can be lowered by using less light from the main light. Do not reduce the fill light.*

Adjustments for Skin Tones: When photographing a black person, it is not necessary to increase the f-stop exposure, since the exposure was based on a 1.90 reflective black, which is darker than the skin tones.

Frank Cricchio

Frank Cricchio

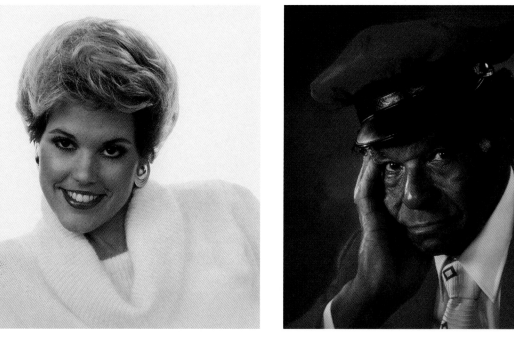

The goal of these tests is to establish the conditions under which you can consistently produce negatives that will print a full range of subject tones.

Status M Red Aim Point Density Readings for KODAK Films

KODAK Film (Film Code)	ISO Film Speed	Gamma Red	Green	Red D-Min	Flesh Density	Gray Card	White Density	Black Density	Diffused Flesh	Gray Card
VERICOLOR III Professional, Type S (VPS)	160	0.59	0.65	0.17	1.05–1.35	0.73–0.93	1.30	0.30	1.10	0.85
VERICOLOR 400 Professional (VPH)	400	0.57	0.62	0.38	1.20–1.50	0.90–1.10	1.53	0.53	1.34	1.03
VERICOLOR HC Professional (VHC)	100	0.58	0.63	0.24	1.10–1.40	.80–1.00	1.39	0.39	1.21	0.92
GOLD 100 (GA) 120-size	100	0.54	0.60	0.30	1.05–1.45	0.90–1.10	1.45	0.45	1.24	0.93
EKTACOLOR GOLD 160 Professional (GPF)	160	0.54	0.61	0.29	0.95–1.35	0.80–1.00	1.44	0.44	1.25	0.94
PCN GOLD Professional* (PCG)	100	0.53	0.58	0.29	0.95–1.35	0.80–1.00	1.44	0.44	1.21	0.90

Available in Japan.

Note 1: All densities are transmission Status M red filter densities.

Note 2: Black densities are referenced from a 1.90 reflective black, using a KODAK Q14 Gray Scale.

Note 3: Diffused highlight flesh is referenced from forehead above nose. Diffused flesh is (White Density) – (gamma x .30).

Note 4: Aim point for black is based on +0.10 to +0.20 above base fog (D-min).

Note 5: White density is +1.00 above black.

Note 6: Gray Card = Black with texture + ½ distance to white.

Note 7: Subtract 0.04 from normal values for films coated on ESTAR Support (i.e., VERICOLOR III Film).

Background-Light Density Test

The fill light and main light should both be operating with the watt-second settings and at distances found to be correct in the fill- and main-light tests. The *f*-stop setting should be *f*/11, as determined by the first test. Again make a test with the background light at 25, 50, 100, and 200 watt-seconds and include an information card for each setting. When the film is processed, ask for 4 x 5-inch prints with equal density in the diffused highlights of the face. This test will identify the correct watt-second setting for the desired background light glow, enabling you to match the subject's clothing tones to the background tones.

Once you have completed these tests, you will have calibrated your equipment and all photographic variables so that you will know exactly the effect that these methods will produce in low-key and high-key portrait photography.

Step 3: Determine the Lighting Ratio

Density tests must be made only once for each new film type. When you have established the conditions necessary to photograph within your film's density range, you can use your exposure meter to help you duplicate the conditions anywhere you choose. Another test must be done to determine the correct lighting ratio, however.

To establish your lighting ratio, you must translate the light intensities you have established in your fill- and main-light tests into *f*-stops. Measure the fill-light intensity by setting your flash meter at the ISO setting recommended by the manufacturer for the film type you are using (e.g., 160 for VERICOLOR III Film). Point the meter toward the fill light from the subject position.

Note the *f*-stop. Measure the main-light intensity in the same way and record both of these *f*-stops. The setup that results from your tests should give you a main-light intensity that is 1½ *f*-stops brighter than the fill light. This is a 4:1 lighting ratio, the maximum lighting ratio that can be used with Vericolor III Film.

Guide Point: *Each different type of film will require a different lighting ratio for optimum results. Films with a gamma of 0.62 to 0.65 can successfully use a 4:1 lighting ratio. Films with a gamma 0.65 to 0.69 will show better results with a 3:1 lighting ratio.*

Once you have established a difference of 1½ *f*-stops between the fill- and the main-light sources, with the meter still set at the manufacturer's recommended setting and its dome facing the camera from the subject position, activate both light sources, and take an incident reading. This reading will give you a starting point from which to make your density test for the correct exposure.

Use your strobe meter as a guide in repeating the setups that have given you the correct density results with Vericolor III or any other film. Then calibrate the meter to find your working ISO film-speed rating for your conditions.

When you have established the conditions necessary to photograph within your film's density range, you can use your exposure meter to help you duplicate the conditions anywhere you choose.

Step 4: Establish a Working Film Speed

Film manufacturer exposure-index (ISO) ratings and light-meter ISO settings may not always be the same as the working exposure index of your light meter. The following test should be made to establish the working exposure index to use with your light meter.

Exposure index is established as a result of testing your exposure meter's medium-gray reference point (18% gray card) to a specific gamma contrast of film.

The gamma of color film remains constant because the processing is an established, consistent procedure. (The gamma of black-and-white film changes with different developing times and different developers.) Because color negative film processing varies only slightly, the gamma of the film is considered to remain constant.

Ed Pierce

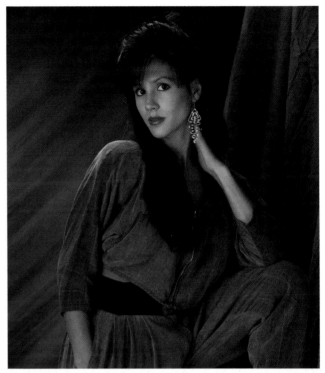

The main plus a reflector illuminated the face. A back light aimed at the subject and a parabolic flash on the background provided separation.

Testing Your Light Meter

1. *Set the meter at the ISO recommended by the film manufacturer.*
2. *Set up a medium-gray reference (18% gray card) and illuminate it evenly.*
3. *Read the light volume with the meter; record this reading and the f-stop on an information card, and place this card in the setup.*
4. *Make an exposure according to the meter reading.*
5. *Make additional exposures at ½-stop increments on either side of the f-stop determined from your meter reading.*
6. *Have your lab develop the film and read the gray-card densities of the developed negatives through the Status "M" red filter of a transmission densitometer.*

Note: *Status M filters are used to read negative film; Status "A" filters are used to read transparency film.*

7. Select the negative that has a 0.85 gray-card density and match the f-stop used to achieve this density.

8. Return to the original setup and repeat your meter reading. Adjust the ISO setting on the meter until you duplicate the f-stop that gave you the 0.85 Status M red filter reading. This setting becomes your working exposure index for this particular light source, environment, and film combination.

Guide Point: *A gray-card reading of 0.85 with a film that has a gamma (contrast) of 0.63 and a lighting set up with a 4:1 lighting ratio (the main light 1½ f-stops brighter than the fill light) will give you a density difference of 1.00 from black with texture to white with texture. It is important to remember that film with different gamma requires different lighting ratios and gray-card aim points to achieve a negative density difference of 1.00 from black with texture to white with texture.*

Frank Cricchio

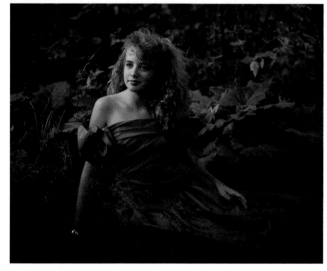

This outdoor setting in open shade required a CC20R color-compensating filter and an adjustment in the exposure index of the film.

Step 5: Determine Exposure Indexes for Other Lighting Conditions

Because you will use film in various lighting conditions, additional exposure tests should be made. Determine exposure indexes for conditions that include:
- Outdoor exposures in the late afternoon.
- Outdoor exposures in open shade.
- Outdoor exposures on an overcast day.

The success of a photographic portrait depends as much on the photographer's artistic and creative use of lighting techniques as it does on his or her skill with the camera.

You will use a different working exposure index (ISO) for different conditions because VERICOLOR III Film is designed to have 160 ISO when exposed with daylight. The exposure index will change when the film is used in conditions other than sunlight.

Guide Point: *In environments where red light is lacking, the exposure of the cyan layer is affected. Such conditions as open shade, late afternoon daylight, and overcast sky result in less red light, and consequently, in the loss of image contrast and film speed. In these situations, adjust your ISO setting to increase exposure. For an extreme loss of red light in your photographic environment, add 20 cc of red filtration and increase exposure by an additional ⅓ stop.*

Exposure Index for Various Lighting Conditions

Film	D-Min	Rated ISO	Strobe Index	Sunlight Index	Open Shade	Overcast
VPS	0.15	160	125	160	80	64
VPH	0.38	400	400	400	320	320
VHC	0.24	100	100	100	50	50
GA	0.30	100	100	100	64	64
GPF	0.29	160	160	125	64	64

Note: A change from ISO 160 to ISO 125 is ⅓ f-stop.
A change from f/5.6 to f/4.5 is only a ½ f-stop increase, not a full stop.

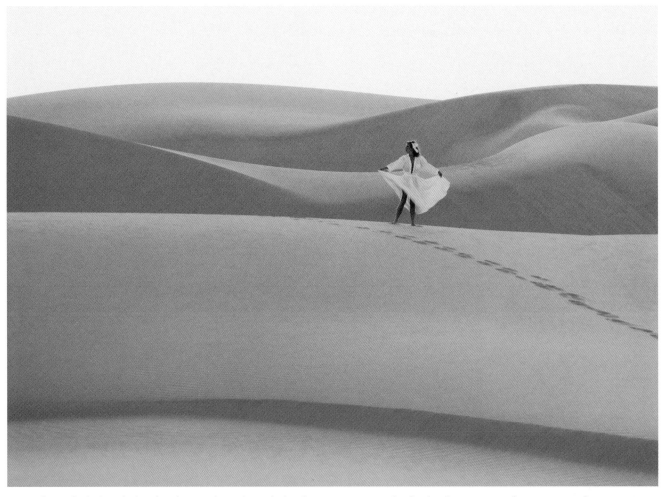

Using the methods described in this chapter, the author calculated a new exposure index for this desert scene under an overcast sky.

To calibrate your exposure meter, repeat the setup you used in the last density test. Set the meter for the film's ISO speed, take an incident-light reading with the meter pointing toward the camera from the subject position, and note the *f*-stop. Compare this with the *f*-stop that gave you the 0.75 to 0.85 density reading on the 18% gray card. If they are not the same, change the ISO setting on the exposure meter until the setting corresponds to the *f*-stop that gave you the correct density.

This new setting will be the working ISO (exposure index) that you will use. From this point, using only your meter, you will be able to duplicate your setup and achieve the correct density for your film. This procedure works with great accuracy because of the many high-quality, dependable exposure meters currently on the market. Once you become comfortable using VERICOLOR III Film and can easily duplicate the

setup that gives you the correct densities with this film, you can begin to refine your exposures and to use the film with both high- and low-key exposures.

Step 6: Understand and Use Appropriate Lighting Techniques for Portraiture

The success of a photographic portrait depends as much on the photographer's artistic and creative use of lighting techniques as it does on his or her skill with the camera. Lighting creates impact in a portrait. High-contrast illumination enhances character and strength in a face, while lower-contrast lighting produces a softer image. You can use the following lighting techniques to create portraits of your clients that not only capture their images, but also reflect their character.

Apply the Incident Principle to Create Impact

As the incident angle of the light is increased away from the camera axis, the reflective quality of that light

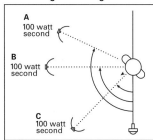

Incident angle affects light reflectivity

The power settings are the same, but light "A" reflects more light off the subject than light "B" or "C" because of its greater angle.

becomes brighter and more specular, even though the incident volume remains the same. How does the incident angle affect the reflective light? Light "A" reflects more light off the subject than light "B" or "C," even though the power of all three lights are the same. This is because light "A" has a greater incident angle.

All lights that strike the subject should have the same incident volume as the fill light. The exception to this is the principal light, which should be 1 to 1½ f-stops brighter than the fill light.

To utilize the incident principle of exposure, set up the studio lighting equipment in two triangles, as illustrated in the floor plan below.

Note: All meter readings are incident. Each reading is taken from the subject with the meter pointed at the light source. The meter must be able to make an accurate reading from a single light source. Set the camera according to the reading from the primary main light.

Add a Second Main Light

Adding a second main light to the setup will create specular highlights which add impact to the lighting. The quality of the second light should match that of the main light. As the second light is moved farther away to

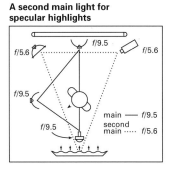

A second main light for specular highlights

The lighting is set up in the form of two triangles. The main light is 1½ stops brighter than the second main and fill lights.

increase the angle from the camera axis, more specular highlights will be generated on the subject's face. Look for these highlights on the edge of the nose. When the second main light is properly positioned, the specular highlights will be sharp and brilliant; if the second light is overemphasized, it will

Frank Cricchio

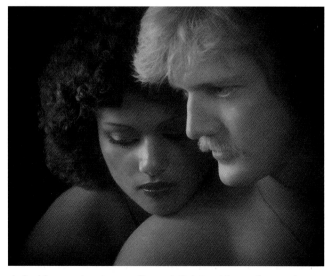

A double portrait using angel's touch lighting. Notice the specular highlights and the slight shadow in the indentation of the upper lip.

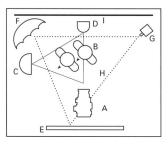

(A) camera—aperture set to main light reading; (B) subject; (C) main light; (D)background light; (E) fill light; (F) second main light; (G) hairlight; (H) gobo; (I) background

make the photograph look unappealing. Use all other lights in the setup in the normal way.

Angel's Touch: There are several ways to use the second main light to achieve specular highlights. One of these methods is to aim the second light at an angle that is perpendicular to the face. This lighting technique is similar to split lighting, where only one side of the face is lit. Light is cast over the bridge of the nose, the coloring of the eye is illuminated, and the appearance of the eye becomes crystalline. At the same time, the light should highlight the lips and glance off the two ridges of the vertical indentation located just under the nose and above the upper lip. This area is sometimes referred to as the "angel's touch."

To highlight the angel's touch, the second main light should be half the intensity of the first main light and should be placed 45 inches from the subject. If this light creates too many specular highlights on the subject's face, halve the watt-seconds or move the light farther away from the subject. The light is positioned properly

when each edge of the angel's touch is highlighted and there is a little shadow in the indentation and some texture across the lips.

The profile is a study of only one side of the face from chin to forehead. The widest and fullest side of the face is most suitable because it usually has the most contours.

Profile: The profile is a study of only one side of the face from chin to forehead. The widest and fullest side of the face is most suitable because it usually has the most contours. In order to avoid having a horizontal line straight across the subject's shoulder, the arm should be placed so that it is an extension of the shoulder line. The camera view should be from the back of the subject's shoulder. Showing the back of the subject with his arm extended and his shoulders in a diagonal position will give a smooth base on which the profile rests.

Start the profile position at ninety degrees to the camera axis, then have the subject turn slightly toward the camera. From the camera's viewfinder, look for roundness on the edge of the nose; a sharp edge will make the profile appear to have been cut out and pasted onto the background. Stop when you achieve the effect of dimension.

For a profile of a male subject, tilt the top of the subject's head three to five degrees toward the background. If your subject looks straight ahead on an axis of 90 degrees from the camera, too much white of the eye will show. To avoid this, after the subject has tilted his head toward the background, have him turn his eyes three to five degrees toward the camera position.

Frank Cricchio

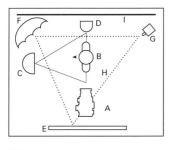

(A) camera—aperture set to main light reading; (B) subject; (C) main light; (D)background light; (E) fill light; (F) second main light; (G) hairlight; (H) gobo; (I) background

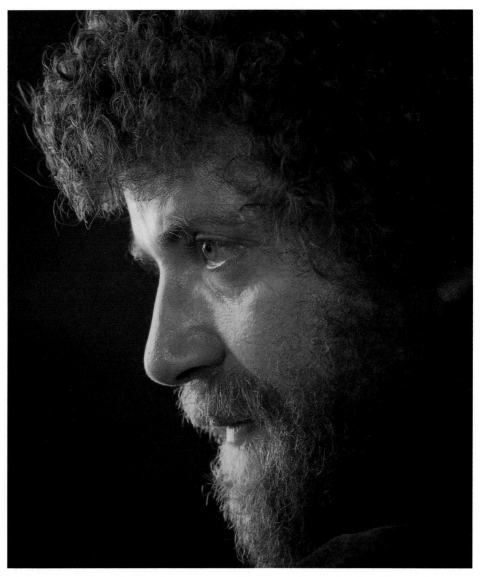

The subject turned slightly toward the camera to add some roundness to the edge of this profile.

41

This setup used short accent lighting to add specular highlights to the side of the face and the bridge of the nose.

The second main light should rim the profile from chin to forehead. Avoid lighting the area under the neck. You will probably have to use a "gobo" to keep spill light from the second main light from striking the camera lens. Bring the first main light across the face to shape the nose and give contour to the side of the face nearest the camera. This light position illuminates the eye and results in a smooth effect on the nose.

If you want your subject's hand in the picture, have him hold a short pencil hidden in his hand so that the position of the fingers resembles a "staircase." Place the hand under the side of the chin away from the camera. This will produce more contour lines and depth in the photograph.

For a female profile, have the subject turn her face toward the camera until roundness shows on the nose. Try to show the two edges of the angel's touch (the indentation under the nose and above the upper lip) without showing the back eye. If the back eye shows, the angel's touch will have to be sacrificed. Tilt the subject's head three to five degrees toward the camera.

(A) camera—aperture set to main light reading; (B) subject; (C) main light; (D) background light; (E) fill light; (F) second main light; (G) hair light; (H) gobo; (I) background

If the subject looks straight ahead, her eye will not appear to be centered from the camera's view. To give the eye the appearance of being centered, therefore, have the subject turn her eyes 3 to 5 degrees toward the camera position.

With short accent lighting, you can create specular highlights on the side of the face and down the bridge of the nose. The light outlines the perimeter of the face and rims the length of the nose.

Short Accent: With short accent lighting, you can create specular highlights on the side of the face and down the bridge of the nose. The light outlines the perimeter of the face and rims the length of the nose. This is an excellent lighting technique to show character in men or to accent a good nose structure. The lighting technique works best on a subject with an oval face; therefore, you cannot use it on many faces.

This is the hardest lighting to set up. The first main light is placed in the standard position to give roundness to the face. The second main light comes from behind the subject at eye level, or 135 degrees from the camera axis. A parabolic with barn doors and diffusers is used for the short accent light and a softbox is used for the main light. The short accent light should produce an incident reading equal to the fill light. The combined reading of the short accent and the main light should be 1½ stops brighter than the fill light. The resulting contrast quality from this combination produces an aesthetic portrait.

Important Points to Remember

- *In practice, negative materials do not respond to ISO ratings for exposure as accurately as transparency materials respond.*
- *The difference in speed between ISO 125 and ISO 160 is only one-third f-stop.*
- *Properly calibrated exposure meters will call for an exposure midway between black with texture and white with texture (18% gray).*
- *Recent tests have shown that most strobe meters call for an ISO setting of 125 to properly expose* VERICOLOR III *Film to achieve a 0.85 gray-card density.*
- *With the fill light only, the 18% gray card has a 0.65 red filter density. With both the fill and main light, the 18% gray card should read 0.85 and the diffused flesh should read 1.10 density.*
- *Light gets brighter as the incident angle increases. Other than the main light, all lights that illuminate the subject should have the same incident reading as the fill light.*

Ed Pierce

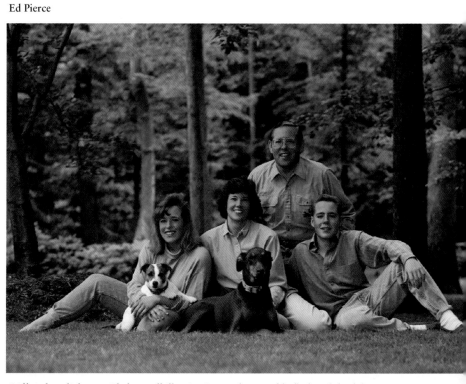

Diffused sunlight provided overall illumination, and a portable flash to left of the camera provided directional lighting and light into the eyes.

MAKING PORTRAITS

BY JOE MARVULLO

Since the beginning of civilization, people have been making artistic representations of other people, that is, portraits. Cave dwellers produced crude but sensitive paintings in rock of their fellow man. The ancient Mesopotamians gave us the first "civilized" types of portraiture in painted statuettes and unique stone personifications of faces.

The Egyptian pharaoh-kings were represented in huge, granite deifications that assured their presence in the earthly world after they departed. Strict traditional techniques were prescribed for artisans, and the first schools of portraiture were formed, giving Egyptian art its highly-stylized look. The Greeks gave sculpture the look of life, the appreciation of the human spirit and form cast in idealized bronze statues of demi-gods. The Romans brought renditions of everyday faces and emperors alike in magnificent bronze and marble busts. Portrait paintings found in Pompeii revealed the study of light, shape, color, and form.

The depiction of the human face as a realistic personage began as an art form. The artist and his or her client are now an established part of the business world. From the first "perfected" deified images of kings and queens through the commissioned paintings of the Renaissance period to modern photography, portrait art has developed into an intimate, personalized interaction between creator and subject. The long and often repeated sittings for painters have now been replaced by the quick, high-intensity exchange of the photo session.

No matter where the location of your shooting session, your relationship with the subject must always flow smoothly. You must maintain a level of self-confidence and professionalism. It is a give-and-take situation where the main goal for both parties is to create pictures that "work." The subject wants to look his or her best, and probably wants to impress people with the photo.

In most cases, you will not have met or worked with the subject before now. It is, in a sense, a blind date. This short-term relationship must produce not only harmony and ease between you and the subject, but it must also yield an image that is as unique as each person you

photograph. You will be like a good therapist breaking through the invisible wall that separates the subject from the rest of the world. You must help the subject shed any public facade that exists and reveal his or her true individuality. You must also make the picture-taking experience a pleasant and friendly one. Interview the subject. Ask how he or she wants to use the photos, about his or her job, if he or she thinks the Yankees will win the pennant; does he or she like sushi? The conversation is critical in creating an atmosphere where the subject can relax and perform, and where he or she feels like a part of the action—a partner.

Duane Sauro

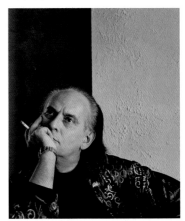

Portraits with maximum impact are those which reveal something of the "real" person.

It is your ultimate decision, however, to determine what is "real" about that person and how to portray it in the photographs. You must successfully translate a distinct human personality in three-dimensional form into a two-dimensional representation. This recorded image must come to life on its own. You, as an artist, must capture the "essence" of your subjects—their persona.

Establish Rapport

When your client arrives at the studio, provide a warm welcome in a professional atmosphere. The environment is very important in the formal portrait sitting. It says something immediately about you, the photographer.

44

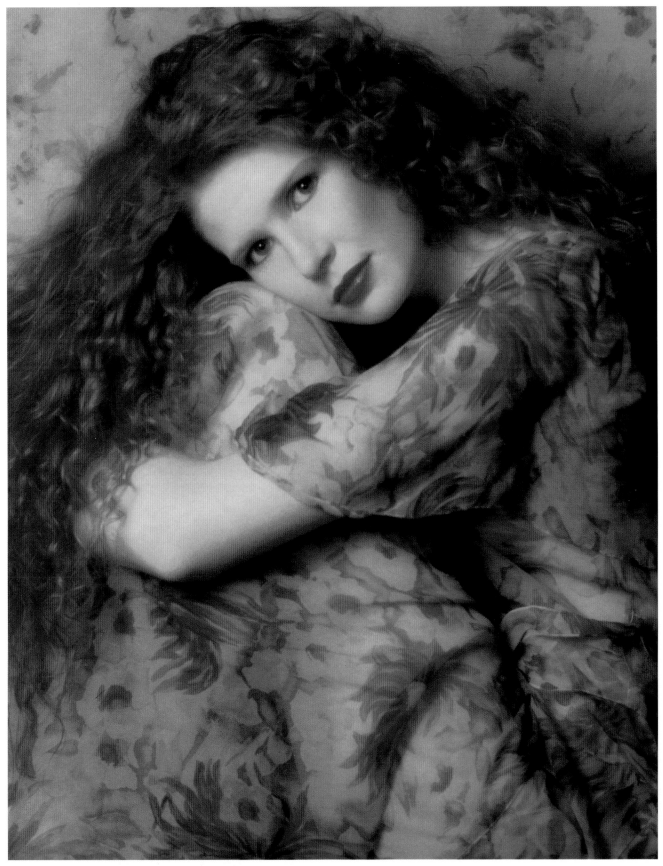

A bed sheet created the illusion of old-fashioned wall paper and provided the color harmony between the vintage floral dress and the background.

© Geraldine K. Mitchell

Make sure the furniture is comfortable. The studio should be clean and well lighted. And be sure to display your work. Have freshly-brewed coffee and other refreshments available. If you have a waiting room, make it a pleasant place with a sofa, magazines, music or a VCR, a restroom, and access to a telephone. The client must never feel like he or she is going to the dentist. Do not keep anyone waiting too long or unattended. And be sure to never make the client feel like just another number in an assembly line.

People respond well to sound not only as a part of the experience of the session, but also as a relaxing escape during momentary lulls in picture taking.

Always hold a pre-shooting conference where the client defines his or her goals and objectives for the portrait. Is it a photo for a loved one; a good, clean public relations shot, an actor's head shot, or a corporate communications portrait? Each one has its own parameters or nuances to be successful. You must elicit the client's ideas about how he or she wants to be portrayed, and then decide what is feasible and how to achieve it in a limited time frame. This meeting is the crucial warm-up session. It is make-or-break time for establishing the relationship.

© Joe Marvullo, 1993

The colors and warm tones of the wall behind this Portugese worker seem especially appropriate for this dignified portrait.

William Wynn

A highway underpass provided the backdrop for this dramatic and individualized senior portrait.

Evoke Personality

It is also the time for "psyching out" the personality of the client and finding the best method for directing him or her during the actual shooting. It is always important to remember that this is a very new and unusual experience for your client. When nervous, each person reacts differently to a situation. The shy type might "completely disappear" and become a subject without any visual personality unless you draw out his hidden character. You have to handle this person differently than the person with a big ego or a false sense of bravado. You will have to build up one personality and bring the other one down. Each photographer's methods will vary, but certain basic ways of dealing with people can help when it comes time for the session.

Music soothes the beast. A sound system that provides background music, in the form of pre-recorded programs (soft music, rock, jazz, and classical), can play a significant role in "softening" the personality of the subject. People respond well to sound not only as a part of the experience of the session, but also as a relaxing escape during momentary lulls in picture taking. I often ask clients to bring their favorite cassettes to play while I'm photographing them. It helps make the shooting situation feel more familiar.

Larry Bilhartz

The artful use of light created this stylish low-key study.

The egocentric type may need an unflattering test shot made with Polaroid film to cut him or her down to size. It will not only deflate the ego, but will make the person work harder with you when you explain what you need to create a more successful photo. The corrected Polaroid photos that are more flattering will establish the right rapport.

You may want to spend more time explaining to the shy and nervous sort taking an informational approach to familiarize him or her with what you'll be doing and demonstrating the poses that you will want. This helps the client feel less awkward and more confident. Conversation and "bedside manner" are the keys to calming the nerves of an inexperienced client. With more outgoing people or those who know the look they want, you can act as director.

Talk out the role as your client poses and give feedback as to what might work better visually. Explain the way the lens sees him or her and suggest optional positions and placement of the arms and hands. Explain how tilting the head slightly changes the angle of the face and can make a more successful portrait. When the subject becomes aware of what is going on and what you are doing, he or she will become totally involved. A better picture will result.

Sometimes you can interview the person while you are making the photographs. Talking will enliven the personality, take visible tension out of the face, and make the eyes appear more lucid and more focused. Getting good expression in the eyes is one of the secrets of good portraiture. Eyes can elicit an emotional response from the viewer. Remember the old saying: "The eyes are the mirror of the soul." Having the subject look directly into the lens provides a point of focus and can help you

to direct easier. You can direct the client to turn his or her head in either direction while keeping central focus. This shows the contours of the face from different perspectives while still maintaining eye contact with the camera.

Personality with Lighting

When you pose your subject under the lights and make test Polaroid photos or use the KODAK PRISM Electronic Previewing System, you "mold" the picture together for the first time. You define what works to bring out the strengths of the client's appearance. The theme of the photograph is evolving. The test pictures are a good point from which to work and helps to develop a team spirit. Choice of lighting will affect the mood of the person and help evoke a particular personality. Testing the lighting will help deal with problem features; use under lighting for baggy eyes, or soft light for ruddy or wrinkled complexions.

In the studio, I follow a simple procedure before testing the lighting on the subject. Even before the person is ready for the actual portrait session (changed into the right clothes and hair done), I do a preliminary test photo just to see how the subject looks on film and how he or she will react to the strobes. This will quickly give him or her a taste of what is to come—something to think about while getting ready. This is a very critical step. It is a quick interaction to build upon and gives you visual

© John Drew

Dramatic underlighting produced an image reminiscent of 1940's film noir style.

47

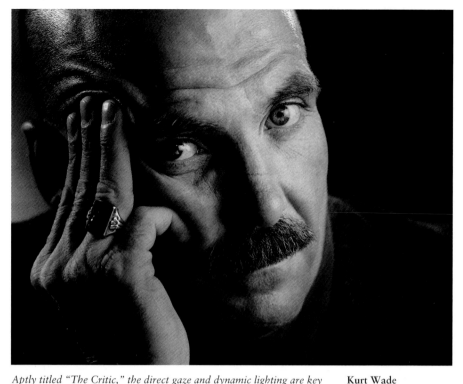

Aptly titled "The Critic," the direct gaze and dynamic lighting are key here. The hand was printed down to bring full attention to the eyes.

Kurt Wade

results from a combination between the angle of the person's face, whether he or she is looking up or to the side, wherever the best contours show and flatter the subject, and whatever the angle of the light source. This is the "dynamic" angle—that magic spot where the three-dimensional shape of the subject is best revealed and troublesome shadow areas are at a minimum and where the lighting and facial angles are at their fullest harmony. The melding of this main light in conjunction with a hair light on a boom is the mainstay of my portrait lighting setup. Together with reflectors, I can obtain any number of portrait styles with these lights. I tilt the lights so that they shed some light on the background and provide some separation from the subject. Although sometimes I use a third light for background illumination.

Another use for a third light is as a below-the-face fill. To achieve an even fill, use either a white or silver "bounce board" right under the face. It will reflect the light from above onto the face. Or you can achieve fill with a direct light in a soft box aimed at an acute angle

For a larger portrait view or a full-length portrait, you will need extra lights to illuminate a backdrop or perhaps furniture or other props.

information to think about and use. It will save a great deal of time later. I rarely show this test to the client. "This," I explain, "is a mere test of the equipment and has absolutely nothing to do with the final shot."

For most "tight" portraits, I use a basic guide for finding the right visual personality for the client. I use one main or key light set at an angle of approximately 45 degrees to the subject, at a high position from above and usually to the right or left of center. This light can either be a soft box, a reflector with tissue for diffusion, or a white bounce umbrella. (This is the starting point for most of my portraits.) This light should be diffused and even in its intensity. I ask the client to move his or her head up and down, and to the right and left, so I can see how the light affects the contours of the face. Each of the three-quarter angles of the face will provide a different portrait of the person. Each side looks differently and one usually looks better than the other, hence the old Hollywood actor's cliché: "Shoot me from my best side only."

It is best to keep the lighting setup to a maximum of two to three heads, including reflectors. When the subject is seated, I use a comfortable, padded stool with a back support. The stool is adjustable for height and is on wheels. I move the key light around (it, too, is on wheels) until I find the lighting I like. The right lighting

from below the subject. This fill light from below helps to remove shadows made from the main hair lights and eliminates any harsh shadows cast by the nose and brow ridges. Its diffusion will soften and clear the skin's appearance. You can also use a third light as a "super fill," shining from directly behind the camera as close as possible to the lens axis. This will remove any cross shadows and add a high-key look to the portrait. For a larger portrait view or a full-length portrait, you will need extra lights to illuminate a backdrop or perhaps furniture or other props.

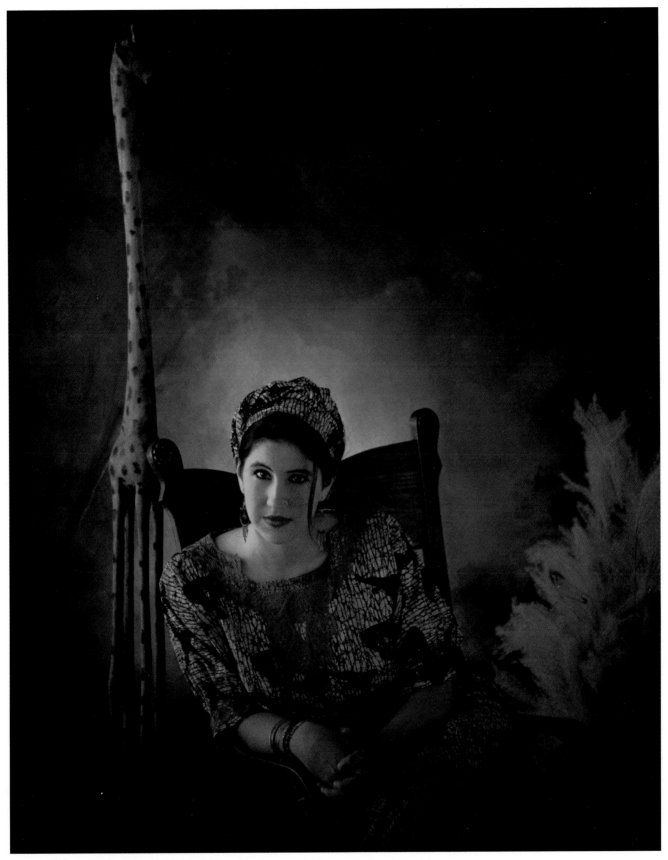

This very personal image was the result of a senior portrait session. The clothing, jewelry, and stuffed giraffe were memorable items from the subject's trip to Africa.

Charles A. Leininger

Larry Bilhartz

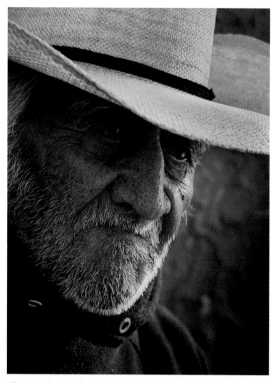

Shot outdoors, the light reflecting from the sidewalk softly illuminated this weathered face. Notice the catchlights in the eyes.

Bring Out the Best

Each photographer uses different lighting techniques. However, some basic guidelines apply for enhancing or minimizing certain facial features. If the subject has a thin or narrow face, you can use "wide" or "broad" lighting to widen the look of the face. Arrange the main light so that it illuminates the side of the face closest to the camera. You can make a chubby or round face look more slender by using "tight" or "short" lighting. In this case, the light is placed so it is shining directly at the side of the face that is away from the camera, creating a shaded effect on the side of the face closer to the camera. When using both lighting techniques, look for that "Rembrandt" triangle of light side of the face that is not being lit directly. Your clients will be pleasantly surprised by the results.

In most cases, position the camera at approximately eye level to the subject. The subject will appear to have direct eye contact when you view the final photo. This prevents distortion to the face that occurs when you photograph at higher or lower angles. However, you can experiment with different camera angles and

different focal-length lenses to achieve certain effects, if desired. Not everyone will appreciate seeing their features exaggerated, i.e., big hands or an egg-head look. But it can be an effective method for communicating the true personality or particular talent of the individual. For example, in a portrait of a surgeon, you might want to exaggerate the hands.

Position the lights to create catch-lights in the eyes that are off-center of the pupil. It adds sparkle and life to the subject's face. For most of my portraits, I stay within the 3:1 lighting ratio, both for color and black-and-white work. This lighting balance usually achieves a realistic relationship between the light and shadow areas of the photograph.

Just as the "broad" and "tight" lighting methods can help change the visual perception of the subject, so can optics make a difference. Various lenses add a creative option to the portrait. A wide-angle lens can help make a wide face appear to be narrow, while a short or medium telephoto lens will give a flatter or broader appearance to the face. You can make unique, distorted photos by using wide-angle lenses focused in close on the subject or by working with macro lenses for ultra-tight cropping or portions of faces for unusual but powerful images. The difference in camera-to-subject distance when

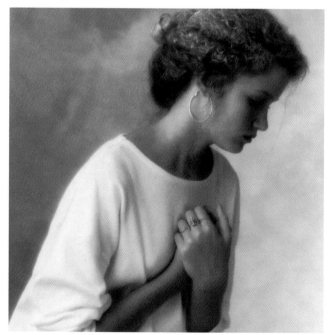

Turning away from the light added a sense of tension and mystery to this subject's profile.

moving from a medium telephoto distance of about 5 feet to a distance of a foot or two (or even less when working with macro lenses) will yield some interesting responses and perspectives to the photo session. With a shorter working distance, keep talking to keep your

A high-key photo with its brilliant whites has a contemporary, clean, well-polished look, whether it is in black white or color. A high-key image speaks to you; it comes alive.

subject relaxed; he or she is not used to someone that close, particularly while under scrutiny. Depth of field plays a major role in this type of shooting. Selective focus, where one part of the face, i.e. the eyes, is sharp and the rest is out of focus, will look unacceptable. Isolating a particular feature or throwing the background out of focus is the domain of the depth of field.

Remember that most subjects are not accustomed to powerful strobe lights flashing frequently in their faces. So make every shot count. Otherwise, your subjects may become "flash crazy," losing their poses and just staring blankly into space. I try to make no more than nine or ten photos in succession.

Then we'll break for a minute or two so that the subject can regain his or her composure and be fresh again. I recommend shooting a little extra film with people who are not used to flash, as there will be some pictures with closed eyes. The novice has to be reassured more frequently and needs more rest periods.

If you use tungsten lights, of course, you will not have the same concern as with strobes. When using continuous-light sources like quartz or tungsten, the subject will feel a little more at ease. But you may have to deal with the heat from the lights and the subject's eyes squinting. During the brief intervals of changing film and lenses, I ask the subjects to keep their eyes closed to rest them. I also keep eye drops handy and refreshments on the set as well as some towels for their personal use. This

must be a comfortable experience physically as well as mentally. Your charm, the personal chemistry that develops between you and the subject, will make all the difference between a dull or an emotionally-charged picture.

Create the Atmosphere

Creating a "visual personality" for the subject and an enhanced environment for the "theme" of the photograph are the central ingredients to the picture idea. The creation of atmosphere in the portrait setting is essential for making a strong image with impact. The mood you introduce will transform the subject's personality into a new reality on film.

High-Key Lighting

A high-key photo with its brilliant whites has a contemporary, clean, well-polished look, whether it is in black and white or color. A high-key image speaks to you; it comes alive. This technique is excellent for glamorous, female portraits or for soft portraits of babies and children. This is the right approach for people with light skin, for blondes, or for an optical contrast as with a dark-haired woman wearing a dark dress. The brilliance of the white, diffused light will give a brightness to the portrait. High-key portraits work well with white paper or Plexiglas backgrounds. The overall feeling should be airy and light.

Tim Walden

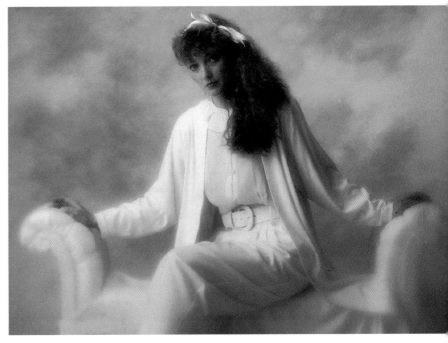

Bathed in soft light, high-key setups are excellent for glamorous portraits of women.

David A. Lloyd

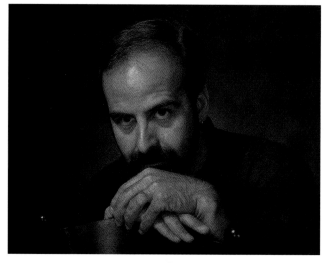

Low-key lighting emphasizes shadows and strength of character—a good choice for male portraits.

Because of the brightness of the light, blemishes and wrinkles are washed out and the emphasis remains on the eyes. This is such a versatile lighting style that it can also be used for children and most tightly-cropped head shots. I keep the lighting ratio at 2:1 between the shadow and highlight areas of the face. I usually "bathe" the subject and set in white, diffuse light by using front lighting with a diffusion screen as well as a top light that is diffused. White reflector cards are on either side of the subject for fill; I use separate lights for the background.

Low-Key Lighting

At the opposite end of the scale, you may want to create a different mood with a low-key portrait. With its dark shadows and low-contrast level, low-key lighting is dramatic and good for strong, male portraits. Low-key lighting defines strong personalities and determined people like actors or executives. Enhancing textures, emphasizing shadows, and adding a dramatic atmosphere to the photograph are the main ingredients for a successful low-key portrait.

The light on the subject must be direct and from a high angle looking down at the subject, creating a shaft of light. A narrow light source works best. Low-key lighting calls for black or dark backgrounds. I prefer black velour for its density. A concentrated light source to the side of the subject, with bounce cards on the opposite end and a snoot on an overhead boom to add a touch of top lighting to the portrait are all that you need to produce effective results.

Remember, keep the lighting only on the essential characteristics of the subject. By isolating certain areas with this hard light, you can accentuate special details and rugged features such as strong chins or aquiline noses. You can use low-key lighting as side lighting to make sexy contours on women in bathing suits or to make portraits where tension is required, such as a graphic portrait of a fireman or policeman. I also use this lighting for powerful portraits of athletes or dynamic pictures of executives. The subject can feel the drama of what you are doing and will respond to it. Test shots on Polaroid Film or by using the KODAK PRISM Electronic Previewing System are important not only in helping you piece together the technical and creative aspects of the shot, but they also allow the subject to see what is happening.

I find working with back light, a traditional photo technique, effective when trying to achieve a soft, ethereal glow in a low-key portrait. The appearance of a halo light around the subject or her hair will give the photo a sensual look. It highlights textures and diffuses facial features, giving the scene a "dreamy" look. Since the light is coming from directly behind the subject, place bounce cards in front of the subject to reduce the contrast levels.

Fill Lighting

You can add interesting highlights by using aluminum foil on the bounce cards to add a hard edged accent to the overall diffused photograph. By using color gels on fill lights, you create layers of provocative color, similar to a painter's approach on canvas. One fill-in spot light with orange and one fill light with amber blended with

Light through the subject's straw hat further emphasized the warm tones of this street portrait.

the white ethereal look of the back lighting can make color a dynamic component in defining the subject. Using an earth-tone gel or filter for portraits of men and bright or pastel colors for women will add an unusual feeling of color harmony or contrast to the final picture. These color gel accents, a mix between traditional rendition and modern technique, provide the photographer with a varied "color palette" for making a statement about the color personality of the subject.

Art Wendt

The careful selection of props and setting established the mood for this nostalgic image.

Diffusion Filters

In the last several years, the use of diffusion filters and texture screens, whether on camera or in printing, has become an art in itself. The results of this type of "beauty" filtration runs the gamut from a well-done and controlled portrait effect to a garish and phony-looking cliché. I use a combination of diffusion filters to achieve various moods and effects. For instance, I find a black TIFFEN SOFTNET diffusion filter excellent for portraits made when using a strobe light because of its tendency to give a "believable" amount of diffusion and still retain contrast and detail. This filter works well with both back and side light.

For a softer, pastel rendition of color (or subtle grays in black-and-white medium) or for general studio lighting and outdoor portraits, I use the white SOFTNET. These filters come in three densities to control the desired effect. Of course, every photographer has his own special home made diffusion filter. My version of a soft-focus screen was made by taking a clear plastic cement and a U.V. haze filter and making a circular pattern of dots around the whole filter, leaving a small clear space in the middle. This is extremely effective when used with tungsten film in available light or with any incandescent light source. Using flash for back or side lighting in conjunction with a filter like this creates interesting patterns of ethereal light around the subject's face, for a unique portrait.

While traditional, conservative portraits will always be in demand, contemporary portraits are very popular today and add excitement or vitality to the portraits.

Make It Contemporary

While traditional, conservative portraits will always be in demand, contemporary portraits are very popular today and add excitement or vitality to the portraits. You can take an ordinary, or what some might call drab, portrait and make it come to life by using a few, simple techniques.

In contemporary portraits, backgrounds are a major element. While plain seamless and painted backdrops are used for traditional portraits, you have the freedom to use abstract and creative backdrops when making contemporary portraits. Also, you can use special-effect lighting techniques on backdrops to create unusual shapes or shadows on the backdrop. You accomplish this by placing grids in front of lamps that project shapes such as stylized skylines, natural objects, interesting graphic shapes, light and dark patterns, and color striations. You can design the "creation" around the personality of the subject and the visual impression you want to convey in the photograph.

There are skillfully-painted landscapes and cityscapes, dappled multi-colored graphics, and surreal Salvador Dali-like scenes.

Textures (both coarse and soft) and unique surfaces such as rattan and bamboo screens, patent leather hangings, drapes (both velvet and translucent), gleaming LUCITE and PLEXIGLAS sheets, and new exotic entries such as gossamer web-like fabrics are available. This

Props and wardrobes are very specific to the particular subject and should be discussed before booking the photo session or at the pre-shoot conference.

array of creative backdrops allows you to set the mood of the scene as well as select color tones that blend with the subject's skin tones and clothing. There are numerous companies offering limitless options for creative backdrops. Many photographers prefer painting or manufacturing their own personalized backgrounds. The ideas are as endless as are the faces and personalities of the people being photographed.

Beau Simmons

Props can help identify and define the subject—a young Naval cadet in this case.

Kent McCarty

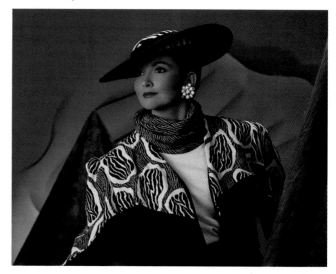

Slits in the gray seamless background complemented the clothing in this high-fashion portrait.

Prop It

Props and wardrobes are very specific to the particular subject and should be discussed before booking the photo session or at the pre-shoot conference. The clothing, unless it is a main focus in the portrait (like a costume or uniform), should not be so flamboyant that it distracts from the person. Simple, well-fitting, tailored clothes that are freshly pressed (an iron should be kept in the dressing room) are the best choice for an acceptable picture.

I find accessories and props necessary only if they define the character, occupation, or avocation of the subject. They can also be useful for providing the nervous subject with something to hold onto, but in most portraits they are of secondary importance and can be a distraction. Of course, in full figure work they can be a viable part of the drama of the scene. But for head shots, they are used only for a particular purpose or to punctuate with color for graphic impact. It is a good idea to keep a selection of jewelry, hats, scarves, gloves, flowers, colorful umbrellas, sporting equipment like tennis rackets and footballs available in the studio for use when appropriate.

On Location

Other considerations arise when making the portrait outside the studio, such as in the subject's home or office or in an outdoor setting. You must consider the portability of your equipment, the problems specific to each location, the working space, the background, the time available for the shoot, the power supply for lights, and, of course, the weather. On location, you must quickly get control of the situation that presents itself.

The photographer waited to use this unique setting until he had just the right subject and outfit. A texture screen complements the mood.

Dennis Craft

The basic survival kit is an extension of your studio. Besides strobes, power boxes, and/or tungsten lights, it is the accessories that can make the shoot successful. Umbrellas act like portable skylights in the quality of light they emit. Umbrella lighting works in offices,

When outdoors, it doesn't matter if you are around the corner from the studio or in Morocco; you are on location and therefore must be self-sufficient.

outdoors (without wind), near windows as fill, or as part of a mixed-lighting scenario. Bounce cards or a large white polystyrene reflector, aluminum foil, tissue paper, extra flash tubes and bulbs, three-prong adapters, plenty of extension cords, gaffer's tape, clamps, a hand-held strobe (as a backup), light stands, tripod, and the

Polaroid back are indispensable. In some instances you must bring a portable system (small stands and cross bar) for a backdrop as a contingency against background clutter and for possible use as a surface for bouncing the lights. In a situation with mixed lighting, an unfamiliar place, or when working under time constraints, the Polaroid check of the set-up, exposure, model's expression, and background is a life saver.

Outdoors

Because of their personality or love of nature, some clients prefer to be photographed outdoors. When outdoors, it doesn't matter if you are around the corner from the studio or in Morocco; you are on location and therefore must be self-sufficient. In this case, less is more. Technical expertise and ingenuity are critical every step of the way.

Site selection is the key to making the picture work. Avoid blinding sun that causes the subject to squint, and avoid disturbing, busy backgrounds. Find areas that look natural for positioning of the subject. Places that are too colorful, like flower gardens, can be distracting. A wooded area is better, its neutral colors will not compete with the model and the soft light filtering through the trees can enhance the portrait. You can use selective focus to minimize disturbing backgrounds and unwanted details in the surround.

Medium telephoto lenses work best for this kind of portrait. The use of a professional lens shade is helpful when shooting portraits in natural light, especially in backlit and sidelit scenes when direct light might enter the camera lens and cause flare. The lens shade is also invaluable when working with diffusion filters and vignetters for special effects.

Charles Lenzo

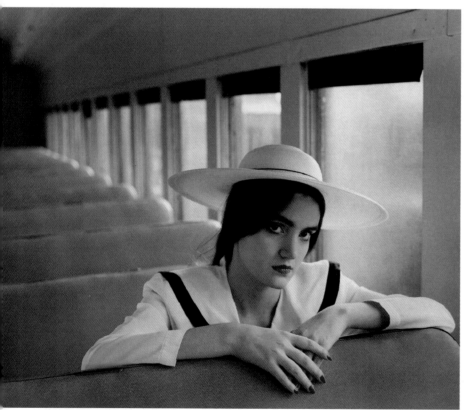

The right accessories can make or break location work. Here, the train windows provided the main light, and a silver reflector provided the fill.

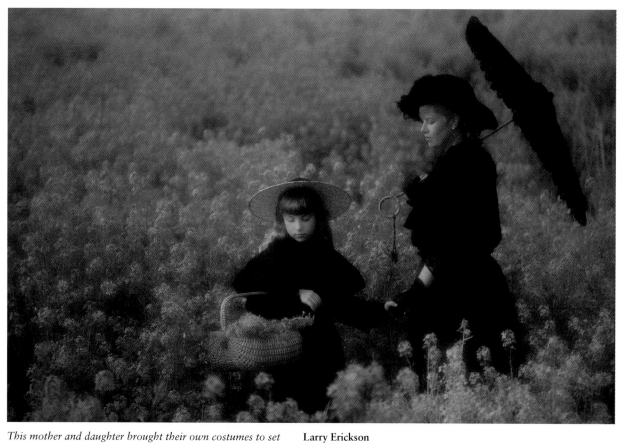

This mother and daughter brought their own costumes to set the stage for this period piece. A soft-focus lens further enhanced the mood of a bygone time.

Larry Erickson

Handy for location work, a ladder provided just the right viewpoint. Careful framing and depth-of-field control completed the composition.

Michael Taylor

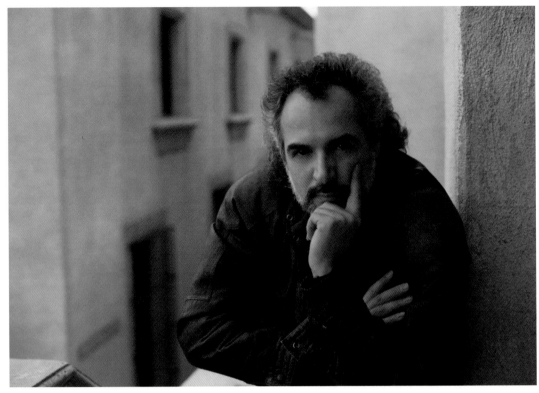

The light of early morning or late afternoon is excellent for outdoor photography.

Try to keep the lighting equipment to a minimum. A hand-held strobe and fill cards or reflectors are basic tools for making environmental portraits. Use white reflectors to bounce light back onto the subject when the light level is low, as in the first or last light of day (both excellent times for doing portraits), or to fill in harsh shadows caused by the strong directional light of late morning or early afternoon.

Try to keep the lighting equipment to a minimum. A hand-held strobe and fill cards or reflectors are basic tools for making environmental portraits.

Fill light helps when the subject is in strong back-lighting as at a beach or on the ski slopes. Natural fill light comes from sand and snow; use reflectors to bounce light back onto the subject's face. You can use reflectors (or silver foil) for dramatic effects by strongly illuminating the subject against the high contrast background or for "rim" lighting where the model is backlit

Jarvis Darville

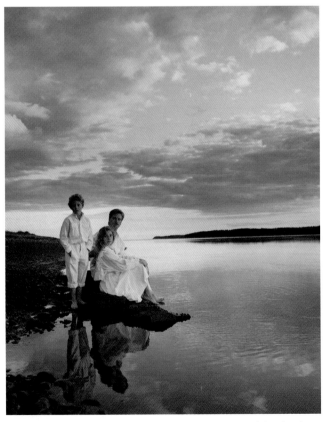

This placid beach scene at sunset reinforced the sense of this family's love of the environment and their closeness to one another.

58

for a halo effect. Rim lighting is excellent for children at play or for beauty shots. The use of a hand-held strobe for syncro-sunlight pictures is another way to supplement the available light, especially when natural fill light is not enough or when you want more specular highlights. You can use warming filters to add a warm feelings to the portrait.

Overcast days give some of the softest and kindest portrait lighting for faces. The light is diffused and without shadows, so the subject has the same lighting as the background. This lighting is good for tight, selective focus head shots since it produces soft skin tones.

The professional portrait photographer must be at ease in every conceivable environment since people seek to be portrayed with greater and greater diversity.

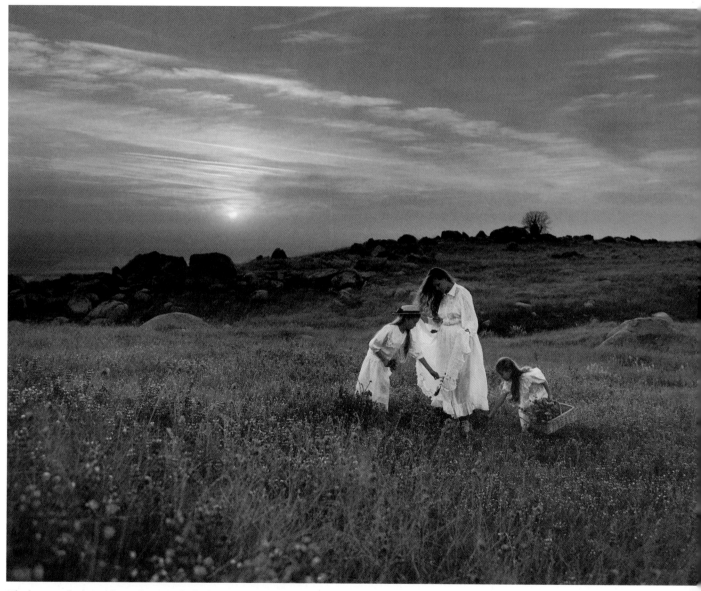

The beauty of relationships photographed in a lovely natural setting can make an environmental portrait a very personal work of art.

Roxanne Pearson

SPECIALTY PORTRAITS

BY DON BLAIR

Portraiture is the art of creating lasting images of people. To me, everyone is beautiful. It is my job to bring out that beauty and capture it on film. This pursuit of truth and beauty has for me been a lifelong obsession—an endless journey upon which I travel each working day. I hope it never ends!

The concept of the portrait has been with us for centuries. My greatest inspiration has come from the "Old Dutch Master" painters. The artists of the Renaissance period strived to capture the most alluring light possible through their own talent and the inspiration they received from natural light. It was through their dedication to the pursuit of exquisite light, falling naturally on their often noble subjects, that they have been able to teach us a great deal about how light can create beautiful portraits.

In these master paintings, we see light literally glow from the canvases. And when we genuinely believe that the light has been true to the subject and the surroundings, we as viewers are willing to believe that the artist has truly captured the soul of the sitter with his palette. The exquisite old masters' paintings have been my inspiration for capturing that same kind of glow through the lens of my camera.

No matter who the subject, where the setting, or what the occasion, it is essential that we guide the light through our lenses to the film that is our canvas. In this chapter, I will attempt to express my love for photography and, in the process, explain how I am able to apply this philosophy to every type of photographic portrait.

Because portraiture is such a broad name for the photography of people, I think it is important to provide some specific insight into how lighting, posing, and other technical concerns enter into what we might call "specialty portraits." These types of portraits include babies, children, teens, high school seniors, family groups, large groups, and executives.

All of these fall under the general heading of portraiture. Many of the general lighting and posing techniques apply in varying degrees to each, but each must be approached with a somewhat different attitude in order to come away with successful images.

Successful images must meet several important criteria; they must be technically good, aesthetically pleasing, and appropriate to the subject. They must also meet and hopefully exceed the expectations of the subject or subjects. And finally, they must meet your own strict standards as a professional photographer.

While the lighting and posing of the subjects are essential to successful portraiture, do not forget the importance of the location and the objects surrounding the subjects. I have always felt that this type of "environmental" concern is essential to capturing the true essence of the person or people whom I photograph.

After all, we are very much defined as individuals because of our surroundings, the clothes we wear, and the manner in which we present our self to others. It is my job as a professional to determine what the important aspects of the subjects' surroundings may be and to turn those specifics to my photographic advantage.

© John Drew

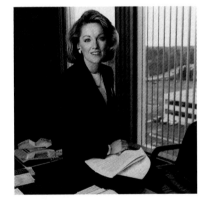

The simple act of sitting down and holding some papers helped this subject to relax.

The monochromatic scheme of this fine color portrait minimized visual distractions to produce a strong and glamorous image.

© Tim Kelly, 1991

Terry Deglau

Maintaining a sense of the surrounding environment was essential to capturing the essence of this busy executive.

The Executive Portrait

Let's consider the special circumstances surrounding a business executive. Often we are more concerned with getting the image on film in the allotted ten minutes than we are with the actual experience. In the process, we fail to reach beyond the superficial. We might come away with good exposure, but they may be less-than-spectacular images. We do not really capture the essence of the subject. Overcoming this requires nothing more than a bit of foresight and preparation.

I consider it part of my job to know about my subjects before they sit for me. You should too. With busy executives, I make it a point to speak with them and others around the office to find out what makes them the successful people they have become. If possible, I visit the setting a day or two beforehand or, if not possible, I try to be there at least an hour or two before the actual sitting time. It can make the difference between success and failure.

Once I have seen the setting and I know where I will place the subject, my only concern becomes the lighting. I want to be prepared completely when the subject arrives, so that all I have to do is fine-tune the lights. This is absolutely critical with a busy executive. When he or she walks in the door, I can focus on interacting with the subject because I have already dealt with the technical details.

While I adjust the lights, I talk with the executive to put him or her at ease. This is when it helps to know a bit about them. From my experience, it is quite likely that the first exposure will be the best. And in many cases, you have only time to grab a few quick exposures before the subject leaves.

Place the subject in a location that puts him at the center of attention. That doesn't mean that he is in the center of the frame, but it does mean that he is the focal point of everything in the scene. There should be no other prominent objects or elements. If there are large foreground or background elements, they should not be lighted more brightly than the main subject. The viewer's eye is naturally attracted to the brightest object in the frame. These tips apply to both indoor and outdoor locations.

Consider, for example, an executive who is in charge of a large manufacturing plant. That plant may be the perfect location to place the subject. Why? Because the setting is an integral part of what that person is and does. The setting also lends itself to a dramatic image because of the foreground and background possibilities inherent in a large plant building.

By placing the subject prominently in the middle ground of the composition, you have the flexibility to look deeply into a dramatically-lighted background

If possible, I visit the setting a day or two beforehand or, if not possible, I try to be there at least an hour or two before the actual sitting time.

that will frame and define the main subject. A carefully-placed foreground object can also serve to draw the viewer's eye into the image and guide it toward the main subject.

Using a wide-angle lens and getting in close allows for full attention right where you want it—on the subject. If your subject is in an office, place him or her so that you are shooting into the corner of the room. This gives the feeling of converging lines, adds drama, and highlights the main subject.

Lighting

For an effective executive portrait, the first thing to consider is the main light. While the main light is often looked upon as playing the key role, I think of it as a foundation for the lighting.

I like to use a high ratio of lighting in a portrait, especially in an executive portrait. It helps to add depth and presence to the image, and it also lends a psychological strength that people like to see in a portrait of a high-powered business person.

Dennis D. Hammon

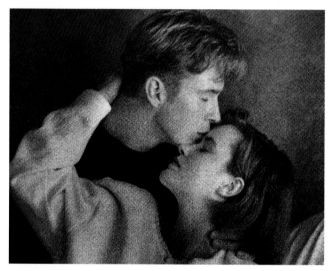

A romantically personal image that was the offshoot of a sitting for this couple's engagement photo.

Use the modeling lights to check your lighting. You will want the light to "wrap" around the subject. In order to create the wrap-around lighting, it is essential to add an accent light that "rakes" across the front plane of the subject. Place this light near and behind the main light and adjust it with a very small beam with a barn door or a snoot. A barn door works better, though, because it is flexible and you can adjust the beam of light so that it is what I call just a "kiss of light."

This "kiss of light" should be at half the power of the main light, so that it does not overpower the main light or burn out the highlights on the subject. What we are really aiming for is added detail in the face and a gentle fall-off to the shadow side of the image. In many cases, I utilize a bare bulb strobe to create a greater roundness and separation between the subject and the background. This also helps in creating the rich wrap-around effect that I seek whenever possible.

When using strobes, it is important to turn off the modeling lights during exposure. This is essential because many of the settings with important foreground and background elements require that the shutter be "dragged." "Dragging the shutter" refers to long exposures up to a minute or sometimes longer that allow the natural light to be recorded in the background, separately from exposure of the main subject. This provides a full view of the environment and it allows the viewer's eye to see into the picture, creating a feeling of depth in the final photograph.

Keeping the modeling lights turned off ensures that the main subject is not part of the background exposure and that there is not a "ghostly" image of the subject in the final photograph. Bear in mind that these are not multiple exposures, but one long exposure which begins with flashing the lights in sequence.

Environmental Portraits, Family Groups, Couples, and Pets

Some of the techniques that apply to photographing executives also apply to other categories of portraits. The bare-bulb technique of adding roundness and texture to the subject works well in many other situations.

James Travers

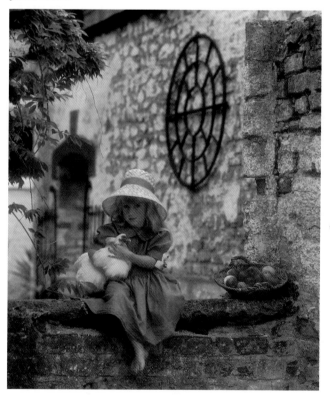

The costume and props perfectly complemented this charming portrait shot in the Irish countryside.

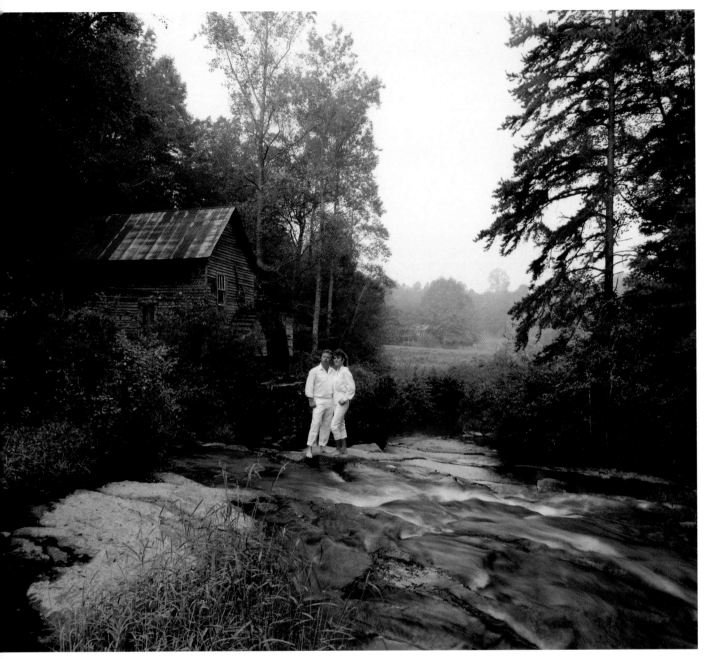

A timeless image photographed by the soft light of early morning. A bare bulb provided specularity, and a slow shuter speed recorded the rythmic flow of the water.

Don Blair

Many photographers often use broad bank or umbrella lighting. While this type of lighting is successful in giving a good negative with a full range of tones in the subject, it falls far short of the kind of carefully-lit image that can win awards and the gratitude of valued customers. The broad "blast of light" approach does not satisfy the need for roundness in the features and it does not flatter the face or body in the way that selectively-modeled and higher-ratio lighting does.

Adding an accent light can highlight the strong features of your subject. The accent light puts emphasis on the area that you as the photographer feel is the most flattering and attractive element of your subject's persona. It emphasizes the beautiful and plays down that which is not.

In making a family portrait, I choose a location that is appropriate for the entire family. This may be an elegant living room for an indoor situation. Also, remember that we want to shoot into the corner of the room to create a pleasing setting for the family to fill.

A sensitive, low-key portrait that well illustrates the fact that fine portraiture is not limited to human subjects.

Charles A. Leininger

Once I have set the stage for the location of the image, it is time to bring in one of the main subjects. Often this is the mother. I will use her as the base for establishing the location of the others in the photograph. This way I do not tire the children, often prone to distraction when sitting still too long.

Jolene Hume

Capturing a cat's personality on film is a challenge for any photographer.

Using Props
With the main person in the scene, I add any final props to the setting. Perhaps I will replace a large plant with a smaller one, or decide to bring in a cherished heirloom like a rocking chair or a piece of sculpture. Anything that defines the family and contributes to the warmth and love that the family feels for one another is a good choice.

Remember, if you do your job correctly here, you are creating an image that the family will cherish for some time to come. You must always bear in mind just how

Remember, if you do your job correctly here, you are creating an image that the family will cherish for sometime to come.

important this image is to this family. Because of this, you should plan for the longevity of the portrait. Try to steer clear of trendy clothing and accessories that could outdate your portrait quickly. Pose the group in a more classic or what some might call conservative manner. While this conservative approach may not allow you to try the latest rage in portraits, the family will not have to put the image in storage because it becomes outdated.

Timelessness is also an important factor from a sales point of view. Perhaps your client wants to build a wall of portraits that shows the family's change over the years. If the portraits have a classic look, the family is more likely to come back year after year for another portrait to add to the collection.

In preparing the setting, I try to put myself in the shoes of the family members. I find out their passions and what they share in common. With my family, it is a love of basketball. I think of how I can integrate that into the final picture. Perhaps the family is very musical and the centerpiece of the room is a grand piano. Or, there could be other valued instruments that the family may want included in the picture. These are all things that I keep in mind when I first talk with the family about their sitting.

Robert Jenks

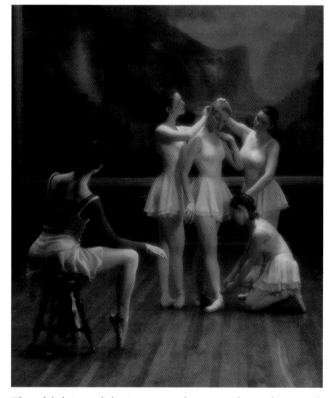

The soft lighting and classic setting evoke a sense of serene beauty and grace. Shot in the St. Johnsbury Atheneaum Art Gallery, Vermont.

Assuming that the setting is the living room and the family will be gathered around the piano, how should you light this scene? To start, use the beautiful natural light that is coming into the room from the right of the subject. It will be your main light. To further enhance the details in the room and the facial features of the subjects, add a bare-bulb flash on this same side close

J.D. Wacker

The overhanging tree blocked the light of the sky and diffused this scene with a soft glow. Portable flash provided fill.

to the camera. The bare bulb will help to bring additional light to the shadow side of the scene and will provide the roundness that I like in my portraits.

Also, it is good to warm up the scene a bit. So far we have a cool balance because of the window light and the bare bulb. You can warm up the scene by adding a back light to help separate the family from the background. Place a table lamp from the living room behind and to the left of the mother. This incandescent bulb

In preparing the setting, I try to put myself in the shoes of the family members. I find out their passions and what they share in common.

provides just the hint of warm back light that you will need to establish a golden glow behind the family.

Finally, add a strobe light that has been "barn doored" so that just a "pinch" of light will rake across the family members. Warm this light with a color gel so that it matches the back light and serves to additionally warm up the entire scene. Now it is time to bring in the children and finalize the pose.

With the children in place—one on the carpet in front of the piano, one leaning against the piano to the left of the mother, and the last child sitting to the right of the mother on the piano bench—you are ready to fine tune the poses.

Looking carefully at the way the light is falling on the subjects, I move them into the light so that the splash of light from the barn-doored strobe is raking across the front of the faces of the subjects. Turn their faces into the main light and their bodies into the shadow.

Remember that placement of hands is very important and can be a key to an effective image. Flat hands are unattractive. Equally, fingers turned in on a flat hand

The second step is generalize the light. By this, I mean establishing the direction and the type of light, whether you will use natural light, studio or portable strobe light, or a combination of the two. You also must determine the general placement or location of the light in relation to the subject's pose.

After that is done, it is on to step three which is to finalize the pose. In doing so, you are preparing the

Doug Hoffman

Careful cropping reinforced the horizontal composition of this family grouping.

can look like claws. Be sure to have the subjects extend their fingers so that they are long and graceful looking, with the edge of the hands toward the camera. Also remember to assure the sitter that what may seem or feel awkward to them comes across as quite natural from the camera's view.

Let's stop a moment to discuss the four categories of the preparation for the photograph. I have broken down the process into four categories so that it is easy to remember the sequence and so we are sure to cover them all.

First, you must establish the overall pose, or it may be referred to as the overall setting. This is where we establish the setting and how we will place our subjects. (Choosing the living room and the part of the room, for instance.)

subjects for the final places they will take, the direction of their faces and bodies, and placement of their hands and legs.

Once the pose is satisfactory, you must finalize the light. You may need to move the lights slightly to conform to the final pose and to give you the quality of light that you need to accomplish an exquisite image. Now you are ready to make the exposure.

When working with families and pets, it is helpful to have an assistant nearby. With dogs it is a relatively simple matter. Keep a ready supply of small treats—approved by the owner of course—which you can use to coax the animal into the right position. Your assistant can train the dog into position by offering a treat whenever the dog obeys the commands. Also, have

An assistant can be invaluable when trying to control and hold the attention of a potentially active group like this.

your assistant use the promise of a treat to get the dog's attention toward the camera. When your assistant is standing behind the camera, it is easy for all eyes to focus on him. This is true with children, too.

Babies and Children

There are some special concerns when photographing babies, children, and other young people such as teens and high school seniors. While the fundamentals of lighting and posing discussed earlier are generally the same for all specialty portraits, it is important to remember some special techniques that can make dealing with these young portrait subjects the most fun it can be.

To start, let's consider the infant portrait. These tiniest of subjects can be temperamental and difficult. But with a little patience and understanding, it is quite simple to take advantage of their inquisitiveness and wonder at everything new in the world. Often parents are wary to bring in their child at a pre-appointed time because a baby's mood is so unpredictable. My solution for this is to set up an appointment with the understanding that it must be flexible. You really have no choice. The parents will appreciate your sensitivity.

Ask the mother to call on the day of the sitting and let you know if all is well with the baby. If all is not well, you can reschedule for another time. Also, try to determine the best time of day for the child based upon eating and sleeping habits. This will make the appointed sitting time more likely to be a success.

Babies are especially good candidates for high-key portraiture because this method brings out the warmth and color of an infant. High key lighting is a soft, open kind of light that invites the viewer to close in on the tiny subjects round and smooth features.

Mother and child photographs are also quite appealing. They are often alluring to the viewer because they emphasize the love and affection that exists between the subjects. You can create these photos in a more-dramatic setting with a longer lens, to emphasize the closeness of the mother and child.

There are some special concerns when photographing babies, children, and other young people such as teens and high school seniors.

In photographing small children and babies, it is essential to have an assistant and some props handy to attract their attention. Your assistant should be behind the camera and create as much fuss as possible to gain the attention of the child. Soft toys, small rocking chairs,

Gregory T. Daniel

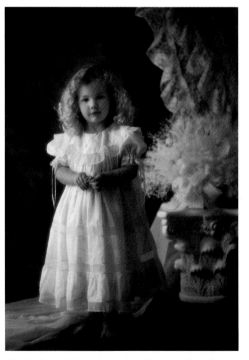

Simply beautiful might be the phrase to describe this photograph. A north-light window provided the soft illumination.

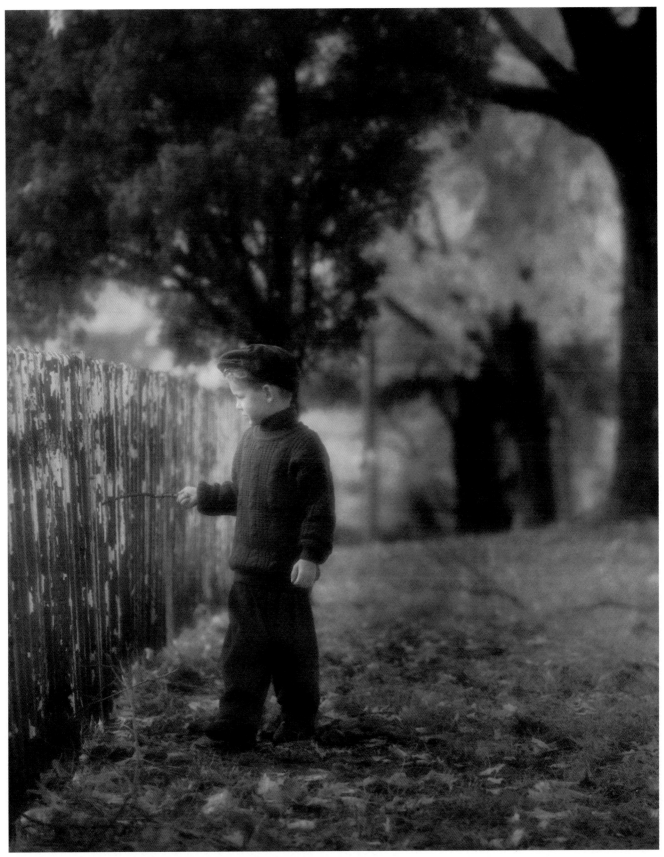

Youngsters often are more at ease in natural surroundings than they are within the confines of the studio.

Dennis Craft

and carriages are all good props both to keep the attention of the child and to set an appropriate mood. While your assistant is distracting the child, you can concentrate on other elements of the photograph, the lights, the pose and the setting.

The baby should be at floor level on pillows or perhaps in a cradle. It is important for the camera to be at the same level as the baby. In doing so, you can relate to the child at his or her own level. Also, by bringing your camera down to their level, you are gaining an understanding for how they see the world. This applies to babies and children, too.

Again, I suggest using a broad parabolic fill light which is supported by a bare-bulb strobe. The bare bulb adds the softness that you cannot get from an umbrella or a bank light. It also wraps the child in soft, open light.

Be aware of the child's clothing. Discuss the clothing in a pre-sitting meeting. Coordinate the clothing so that items like blankets and props have colors that complement one another. When photographing children (or any

Gerald Schlomer

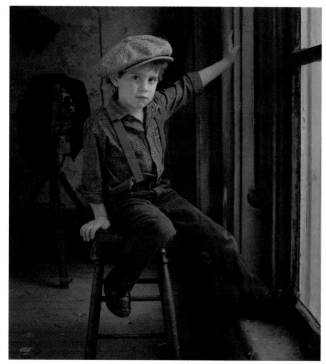

The soft lighting and a costume appropriate to the setting suffused this scene with a sense of timelessness.

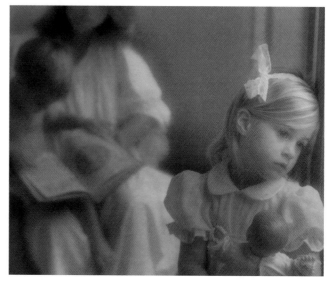

Many successful portraits are an emotional, storytelling moment in time.

subject) outdoors, it is important to dress them in clothing that is appropriate to the setting. It would not make sense to photograph a child wearing a suit next to a babbling brook. Also, in today's more-casual world, it is appropriate for children to wear comfortable and sporty clothes in such rustic settings.

As the photographer, you should dress casual to put the subjects at ease. It is also important to limit the number of people at the location so that the children are not confused or distracted. One or both parents and no others should be present.

It is easy to capture natural-looking images outdoors with a minimum of equipment, yet still create sophisticated portraits. Let's assume that you are photographing two children in a wooded setting outdoors on an overcast day. You can turn this into your advantage with a minimum of effort.

First, establish the direction of the light and place the children so that the light falls on them in a lateral direction. This means placing the subjects so that they are protected from the light on one side by a barrier of foliage. This barrier provides the necessary shadow for a well-modeled portrait. If possible, place children so that foliage is also overhead. This will serve to block harsh overhead light and reduce the possibility of "raccoon eyes" on the subjects. If this natural foliage barrier is not available, use a black gobo or umbrella to create the same effect.

With the basic pose ready, the general lighting is also somewhat ready without any effort. You simply need a fill light to supplement the main light from the sun. Again, I suggest a bare-bulb strobe (portable) that you can use to provide a wraparound effect and create a pleasing, specular highlight or on the more-defined facial features. Often, I add a warming gel to the bare bulb to create the warm feeling of a sunset photograph.

Children's portraits often work best when the subject is happy at play.

Now you must finalize the pose. With children it is important to let them do what comes naturally, with a minimum of direction. Children can become uncooperative if they feel they are being overly manipulated. Try to make a game out of this part of the sitting so that the children are at ease and are as natural as possible. It is not necessary to demand a smile. If their smile is not there, you will only increase the child's resolve not to smile by insisting upon it.

Once you are satisfied with the pose, fine tune the light. If you have more than one subject, you may want to add an accent light. This is what I sometimes refer to as the "garlic light." It is a controlled light with a barn door that adds just a "pinch" of light to the fine features of the subject. I call it the garlic light because I only want to use enough to add some spice or flavor to the subject. It is the final ingredient required to turn a dull flat image into a stunning, exciting one.

Teenagers and High School Seniors

Be sensitive to the particular concerns that teens have for acceptance among their peers. They want to feel that they fit within the mainstream of others their own age. This may mean that they are nonconformists in the adult world, but that they are part of the "scene" in their own world. Be aware of the latest trends in both clothing and hairstyles, and try to be sensitive to their requests for particular settings and poses. For teens, it is necessary to let them feel that they have control. Your job is to suggest possibilities and give them reinforcement and reassurance that they look great.

With children it is important to let them do what comes naturally, with a minimum of direction. Children can become uncooperative if they feel they are being overly manipulated.

Also remember that they may not feel comfortable with a parent around. A friend makes a better companion in this instance. As difficult as it may be, you must assure the parents that you have their interests in mind as well and that you desire to provide them with a photograph of which they will be proud.

As with most subjects, success with teenage portraits comes from putting the client in an environment that works well with their clothing and personality.

It is important to recognize the two types of "senior" portraits. There are those created for use in a school yearbook, which must conform to certain dimensions that will reproduce well in print and those that are for friends, family, and display, which can be more daring and of a higher lighting ratio for dramatic appeal.

Seniors like activity and bright colors in their portraits. They also like the latest music blaring in the background as they pose. While it may not be your favorite music, remember who it is you are trying to please. Make the sitting as much fun as possible. Ask your subject to bring along a friend or two. Photograph them together and work quickly to keep the energy level high.

Try to photograph several different settings with perhaps a clothing change as well. To stay on schedule, you can book several students at once and, while one is changing, you can photograph another. Use unusual backgrounds and props like brightly-colored geometric shapes and large numbers that spell out their class year.

If you provide the seniors with several poses that they think will impress their friends, they will be cooperative when you ask them to pose in a more-traditional setting to satisfy their parents.

© Kathy Wierda

Group portraiture offers the chance to record relationships as well as people.

Tony Colomar

Conceived as a publicity photo for a theater group, the symmetrical composition and the balance of masses created a classical image.

Group Portraits

A collection of several people for a group photograph is always a daunting experience. Where do you start? How do you set the pose so that everyone is visible? How do you light them so that the light is still attractive and effective? Somewhere along the way we are all faced with such a challenge.

If you provide the seniors with several poses that they think will impress their friends, they will be cooperative when you ask them to pose in a more-traditional setting to satisfy their parents.

First and foremost it is important to remember the fundamentals of lighting and posing. These basics are really not much different for large groups than for individuals or couples. What may be a little more challenging, however, is to capture the relationship that these people have to one another. Whether they are a large family, a club, a group of co-workers, or an orchestra, they are still individuals who must be captured collectively on one frame of film.

One of the first things to consider is the makeup of the group. Are they family members, perhaps posing for a family-reunion photograph? If that is the case, how does the group break into subgroups? Determine this and place them together. Consider the sizes of each person and how they will come together to create a pleasing composition. Perhaps all the grandchildren will be grouped together rather than with their respective parents.

Establish one or several "planes" to place individuals in the group. These planes will make it simpler for you to finalize your lighting and allow you to include everyone within the camera's range of focus. Sometimes a setting, such as a staircase or a gentle-sloping hillside, can provide you with a natural organization of planes.

In terms of lighting, the same rules apply as to those of conventional portraiture, only on a grand scale. Be aware that there must be a full main light. I like to supplement the main light with my bare-bulb strobe, which in some cases may require several strobes to meet the requirements of the entire group.

Finally, placement of the accent lights is critical in highlighting the individuals in the group. With the planes of subgroups established, you can use accent lights to add depth and perspective more easily.

Pre-planning for any sitting is essential; it is more than essential with large groups. It provides you with a wealth of knowledge about what to bring, what is already there, and how you can begin when the people start coming in the door.

When the fateful moment begins, it is extremely important to remember one special aspect—stay in charge! You must be in control of the group at all times because, given a free moment, they will fall into chaotic disorder from which you will not be able to recover.

There is no question that there are as many ways to make a portrait as there are professional photographers. What I have provided here is designed to give you a small insight into some of the ways in which I make my most pleasing portraits. You can use these ideas and blend them with those you already know to perhaps come up with a distinctive style all your own.

Ed Pierce

Consider the makeup of the group. In this reunion photo of sixty-five people, color-coordinated clothing identifies each family.

Ed Pierce

Large gatherings are a good opportunity for additional photographs of individual subgroups.

WEDDING PHOTOGRAPHY

BY DENIS REGGIE

As one of the important rites of passage, a wedding is the culmination of months of detailed and exhausting preparation. It is the fulfillment of dreams and lifetime expectations. The wedding photographer does more than simply record these events—he or she is preserving cherished moments of a family's history.

Wedding photographers must have a creative, empathetic perception of such moments. The key is to understand and capture the essence of the occasion and to reveal a genuine sense of joy and emotion. There will be no second chance and little margin for error in putting these moments on film.

Traditionalist Versus Photojournalist

There are two approaches to photographing a wedding, the traditional and the photojournalistic. Of course, there are variations in both styles as well as crossover between the methods.

In simple terms, the traditional approach is to isolate and concentrate on the wedding participants (i.e., the bride, groom, attendants, families, etc.), producing a planned series of portraits. These images are created typically during a wedding-day session, where the photographer poses and directs the subjects to achieve a desired result. Often the photographer relies on exact lighting and body-positioning techniques. The traditional photographer supplements the formal portraits with a

David Ziser

Traditional wedding photography concentrates on the participants.

number of "action" photographs, many of which are staged, prompted, or in some way enhanced. Posed photographs often comprise eighty percent or more of the overall traditional coverage.

The more contemporary, photojournalistic approach, on the other hand, concentrates on the events of the wedding as they naturally occur. The photographer works unobtrusively, without posing, prompting, and often without active subject awareness. The photojournalist usually takes considerably more photographs, but with little intrusion or interruption. Posed photographs are few, usually comprised of a limited number of quickly-gathered groups, and account for twenty percent or less of the overall coverage.

Clearly, the attitudes and approaches of both these types of photographers are different. Traditionalists command attention (and obedience) as they go about their people moving, lighting, and posing; photojournalists seek quiet invisibility to facilitate the documentary process.

Just as these approaches are different, so are the typical consumers of the respective coverage. Generally speaking, clients opting for traditional coverage are likely to have fairly large (photographic) wall portraits displayed in their homes. These clients value the work of the master photographic portraitist and, for the occasion of the wedding, solicit the photographer's direction and guidance in creating classic, time-honored portraiture.

Typical clients of wedding photojournalism are less likely to use personal photographs as wall decor. They usually display only smaller, table-sized framed photographs. These clients tend to prefer natural documentation of the wedding, without active direction by the photographer.

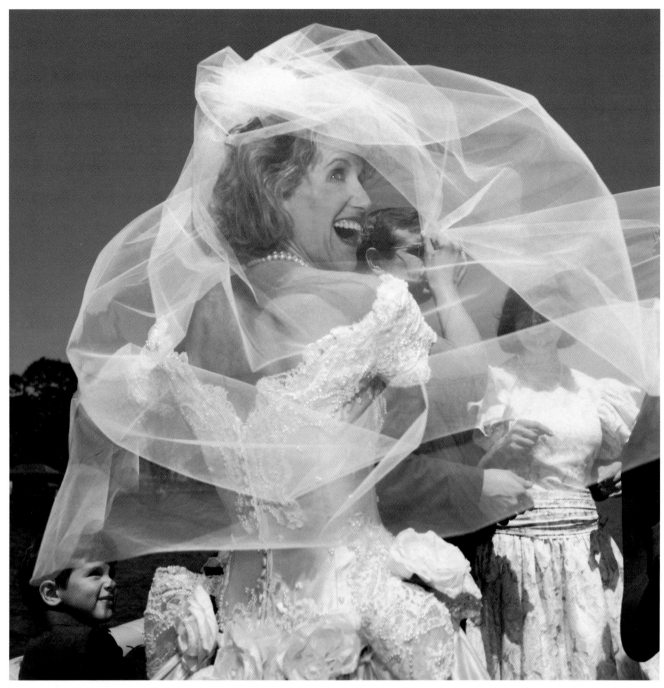

The essence of the photojournalistic style of wedding photography is capturing unposed moments that tell a story.

Denis Reggie

Clay Blackmore

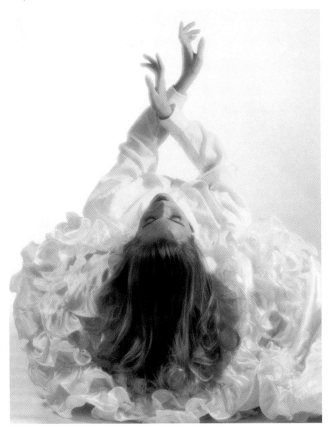

An image reminiscent of a Hollywood glamour picture. Exposed on KODAK VERICOLOR III Professional Film.

Historically, the portrait approach has been the over-whelming style of choice for the professional wedding photographer. Today, while the traditional method maintains a healthy following, there is a growing number of contemporary couples who prefer a less predictable, more intuitive record of their wedding. Wedding photojournalists, myself included, have been quick to respond with less structured, non-fictional coverage. Though numbers still favor the portrait school, momentum in today's market appears to be toward the more natural style.

Equipment

There are as many opinions on "the right camera format" as there are numbers of formats. Style of coverage, ease of handling, and, of course, personal preference are all factors in making the right camera decision.

I usually bring a total of three cameras in two different formats to my wedding assignments. The bulk of my coverage is done with cameras in the 6 x 6-cm (2¼ x 2¼-inch) format, primarily because I like the square shape for visually pleasing composition. A square format means that I avoid having to reposition my flash

unit constantly in the correct orientation above the lens. In addition, I am able to offer my clients larger photographs (10 x 10 instead of 8 x 10-inch size) without substantially greater cost. I can group four 5 x 5-inch photographs on a page, and thus bypass the common difficulty of mixing vertical and horizontal prints on the same page. For these reasons, in both taking the photograph and in presentation to the client, I find the square format ideal for professional wedding photography.

Style of coverage, ease of handling, and, of course, personal preference are all factors in making the right camera decision.

For most of my photography, I use the HASSELBLAD 503CX camera equipped with the 50 mm DISTAGON FLE lens and a METZ 60CT-4 flash unit. This camera features an accurate TTL (through-the-lens) flash metering system that controls the output of the flash unit. I attach the appropriate TTL flash module (SCA 390) and, to minimize shadows, I mount my flash unit directly above the lens with a STROBOFRAME bracket. This outfit permits me easily to direct my flash upward for ceiling bouncing, while the TTL system instantly regulates the flash output for the selected film speed and aperture setting.

Denis Reggie

The less traditional journalistic approach generally means working unobtrusively without posing, and often without the awareness of the subject.

I mount a second HASSELBLAD 503CX camera on a CULLMANN TITAN CT100 tripod and use it primarily for available light and time-exposure photography. Though most of my work is with the 50 mm (wide angle) lens, I also tote the 80 mm (normal) and 120 mm (short telephoto) lenses to each assignment. I use four film magazines; two are the 24 exposure (220 size) film magazines and two are the 12 exposure (120 size) film magazines. Both of my cameras are also equipped with prisms that contain light meters.

When the wedding occurs at a time and place with sufficient available light, I am able to also use a 35 mm auto focus camera for quick, "grab" photographs. I use the CT F4 camera with the 35 to 70 mm, *f*/2.8 lens, carrying the camera by its strap over my shoulder. This third camera is ideal for fast action moments that I can capture with only one hand, allowing the camera to perform focusing, metering and winding functions. Occasionally, I mount the camera on a tripod and use longer lenses (180 mm or 300 mm) to "pick out" key persons in the wedding party or congregation without distracting from or intruding into the wedding.

The NIKON F4 camera features a built-in motor drive. The manufacturer provides a setting for quiet winding which is ideal for in-church use. One other feature of interest to wedding photographers is a computer-assisted focus tracking system that allows the camera to ensure sharpness by anticipating the exact position of a moving target (perhaps the bride being escorted down the aisle by her father).

Film

Technological advances in camera equipment have not been alone in aiding the modern wedding photographer. Today's faster-speed, higher-definition films have also made it possible for wedding photographers to work at previously-unattainable speeds in achieving professional quality results.

David Ziser

Outdoor locations are very popular for wedding photography. Such images make a dramatic addition to the wedding album.

Because high-quality prints are the usual medium for most wedding photography (either for albums or to be framed), professional negative films are the choice of most photographers. Many of these films rely on "T-GRAIN" Technology, which has redefined the level of sharpness and resolution that you can achieve.

A great advance for modern wedding photography, particularly wedding photojournalism, is the development of KODAK VERICOLOR 400 Professional Film (VPH). I use this film in both the 220 and 35 mm film sizes for nearly all of my wedding coverage. The film's fast speed allows me to utilize the existing light in a reception hall, for instance, and to bounce flash off of high ceilings. The film renders flattering skin tones without excessive contrast, and, unlike other films I have used, I find that the stated film speed is nearly right on. Based on my testing with the professional lab that does my color printing, I rate VERICOLOR 400 Film at the specified ISO 400 for any situation from bright daylight to indoor flash photography.

In addition to the VERICOLOR 400 Film, I pack a couple of rolls of KODAK VERICOLOR II Professional Film, Type L (VPL) in the 120 size for non-flash photography of the church interior and for time-exposure photography. This film, which I rate at ISO 100, interprets the scene with saturated but very realistic tones, and without the yellow-orange cast characteristic of daylight-balanced films under indoor, tungsten light conditions.

For couples who prefer black-and-white coverage, I choose another product of T-GRAIN Film Technology, KODAK T-MAX 400 Professional Film (TMY). Here again, I rate the film as specified on the box at ISO 400.

A great advance for modern wedding photography, particularly wedding photojournalism, is the development of KODAK VERICOLOR 400 Professional Film (VPH).

Monochromatic coverage offers a welcome deviation from the customary color work, and, since it promotes the use of contrast and texture for visual impact, it offers artistic challenge as well.

Katherine Dye Payton

An introspective moment that captured the anticipation of the bride-to-be. The glamour of a high-key portrait is popular with many clients.

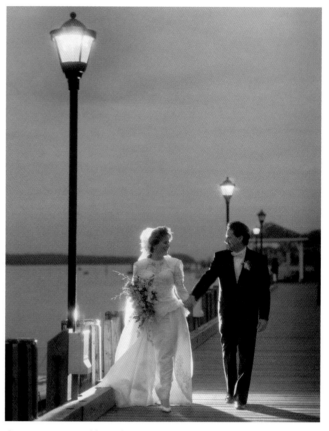

Contemporary wedding photography embraces both traditional and non-traditional styles.

Lighting Techniques

From the photographer's point of view, it would be splendid if weddings could always have illumination that permitted high-quality, existing-light photography. We could not only work with less equipment, but we could always achieve unmistakably natural results. In the real world, however, supplemental lighting is nearly always required, although the desire for natural looking lighting is not lessened.

One of the concerns of using flash equipment at a wedding is the problem of backgrounds being rendered as very dark, nearly-black expanses. To overcome this problem, some photographers successfully work with assistants who direct a synchronized, second flash unit either directly toward the background area or upward for ceiling-bounced, overall illumination.

My aim, however, is to work very quickly and unobtrusively at the wedding, and, accordingly, I rarely work with assistants. I address the problem of unlit backgrounds by using my single on-camera flash unit with

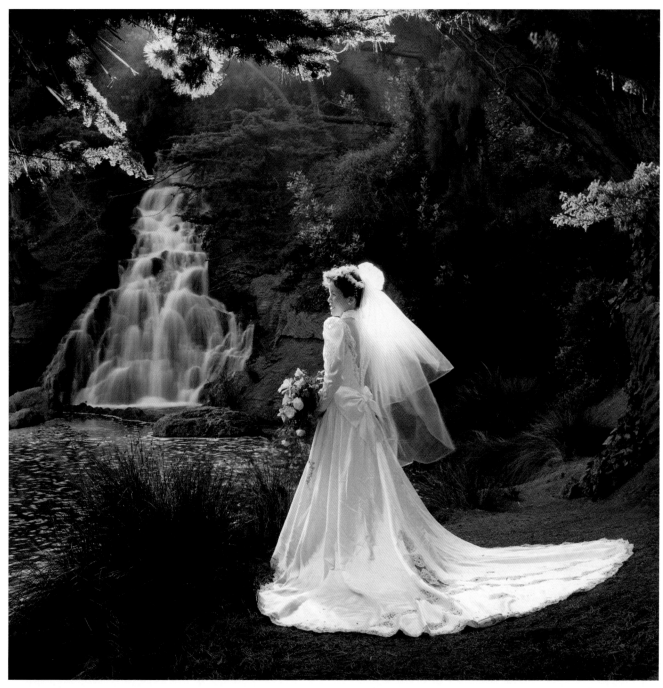

The back light of the lowering sun set a romantic, airy mood.
Exposed on KODAK VERICOLOR III Professional Film at
f/11 for ½ second.

Edmund Lee

an accessory device that allows me to create a "stereo" lighting pattern. Additionally, I rely on the existing room light to become an integral part of the exposure and to thus effectively yield a more natural photograph.

Pointing the flash unit upward, I attach a LumiQuest bounce flash device (either a 80-20 or 90-10 model, depending on the ceiling height) which allows most of the light, eighty to ninety percent, to pass through holes in the unit toward the ceiling. The light coming from the ceiling illuminates both the subject and the immediate background area. The LumiQuest device directs the remaining light, ten or twenty percent, forward to fill in the otherwise shadowed facial areas, especially the eyes.

Using such an accessory, my single flash unit effectively yields two paths of light, both of which are "softened" by being bounced from larger surfaces, the ceiling, and the device itself. Stereo bouncing devices represent a quantum leap from the days of index cards attached by rubber bands because virtually all of the light is being properly directed for illumination of the subject and the background.

I find the quality of the light produced by these accessories to be even better than that produced by the popular dual-head flash units. The micro-sized second flash head built into the handle of this type of unit is not able to produce a broad-enough, forward light source.

David Ziser

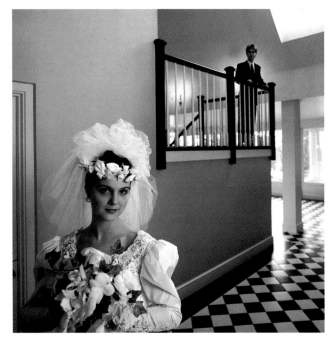

Strong graphic elements and a carefully controlled combination of natural and artificial light were key to this imaginative portrait.

Stephen Rudd

Photographing the bride with a family member brings a nice touch to the wedding portfolio.

The success of exposures made with stereo flash lighting combined with the existing room light relies on the use of fast film. While using films with ISO 400, most professional flash units can reach even the highest reception-hall ceilings and still yield an acceptable exposure. Additionally, depending on the camera setting and light level, existing light in the room can often be a substantial part of the overall exposure. I typically work at $\frac{1}{60}$ second or $\frac{1}{125}$ second (if there is subject motion), at f/5.6 with my flash unit set for TTL automatic exposure. In virtually all situations, I have the flash head pointed upward with one of the LumiQuest accessory devices attached to broaden and soften the light quality.

The two versions of the stereo bounce devices offer lighting ratios suited for either eight to ten foot high ceilings (the LumiQuest 80/20 unit) or for eleven to twenty foot high ceilings (the LumiQuest 90/10 unit).

A third device, the LumiQuest Pocket Bouncer, directs all of the softened light forward (only one direction of light), and is ideal for outdoor fill-in flash and for situations where ceilings are not usable because of color or height. For late afternoon use, I often attach reflective gold material to the Pocket Bouncer to add warmth to the flash illumination and to provide a better match for the existing light.

These bounce devices widen the light path to accommodate most wide-angle lenses, eliminating the need for snap-on diffusers. Changing between the units is accomplished easily by Velcro material placed on the flash unit and each device.

No matter what equipment you choose, you must be prepared for any failure. Adequate backup gear includes flash sync cords and batteries. I also pack lens-cleaning

Whether the setting is familiar or not, I check out the location in advance at the same time of day as the wedding to plan lighting and camera angles.

tissue, screwdrivers, and a mini-flashlight in my case. For a portable umbrella lighting system, add electric outlet adapters, extension cords, and a spare modeling light bulb. I also bring along a second flash system, not only to act as a reserve unit, but to be utilized for double lighting of formal photographs (described later in this chapter).

Preparation

The level of preparation will vary from photographer to photographer, but all will agree that careful attention to details, planning, and consideration for the client are paramount in successfully recording a wedding.

First, about a week before the wedding, I call or meet with the bride to review the schedule of the day, and I take written notes of any particular photographs that she wants. For instance, if an old friend is traveling from a great distance, or if the bride will be carrying an heirloom handkerchief, I can be aware of and act on this information. I also like to know the wedding colors and the number of people in the group shots so that I can better select locations for formal photographs. At the same time, I can take care of such practical matters as rechecking the couple's new address in order to make contact after the wedding. The bride appreciates this opportunity to ask any questions that she may have.

Next, I contact representatives of the various facilities being used on the wedding day. Often, churches, synagogues, hotels, and even reception halls have restrictions and procedures that photographers must follow. Many of these facilities provide booklets or information sheets which outline their photography policies, but even if they do not, it is wise to make sure by asking the individual in charge. If a wedding coordinator or outside videographer is to be working on the wedding day, I make contact in advance as a professional courtesy to discuss general operating logistics. If photographs are to be taken before the wedding, I make certain that flowers will arrive in time.

Whether the setting is familiar or not, I check out the location in advance at the same time of day as the wedding to plan lighting and camera angles. This visit helps in the selection of specific equipment and film for the assignment. I take note of windows, potentially troublesome mirrors, the height and color of the ceilings, and the availability and location of electrical outlets.

Finally, I find out which florist, bridal shop, caterer, tuxedo supplier, band, and baker is involved with the wedding. Personal contact with the vendors, perhaps offering a complimentary photograph from the event, can be invaluable in building new business.

Don Blair

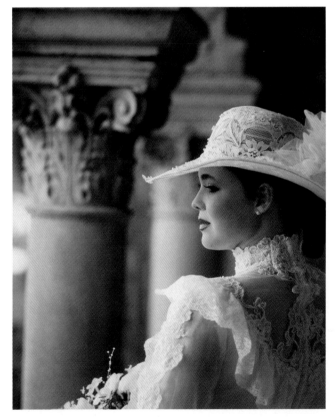

This radiant profile was made by natural illumination. The building overhang effectively softened the ambient light.

Amy Rader

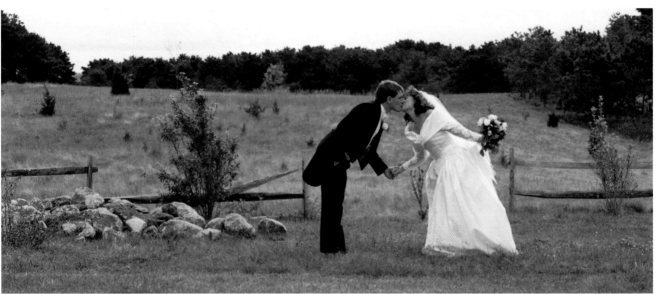

Spontanaeity and good timing combined to make this happy photograph a success.

Pre-Ceremony Coverage

The exhilarating moments preceding the wedding ceremony provide opportunities for many favorite photographs of the excitement and anticipation that surrounds every bride. My coverage begins as the bride prepares for the wedding, usually at her home, but sometimes at the church, or synagogue, or wherever the wedding takes place.

Because most homes or bridal dressing areas have 8 to 9 foot ceilings, stereo bounce lighting is the ideal choice. Not wanting to create a disturbance, I enter the location prepared for action, with my camera at my side. If possible, I avoid bringing extra equipment or camera cases into the home or dressing area, and carry several rolls of film in my pocket.

My initial wedding day encounter with the bride and her family is important because it sets the tone for our interactions during the whole day. I like to lower the bride's understandable anxiety by asking (in a soft voice) that she simply "be herself and forget that I'm even there." Soothing conversation often makes the bride visibly more relaxed and less cognizant of the camera. I am then able to observe happenings without them having to revolve around me; I have established an environment for documenting events as they naturally occur.

It might be the father carrying out the luggage to the waiting limousine or struggling with his bow tie. Perhaps the groom has sent a special floral arrangement, or maybe it is the door of the refrigerator covered with wedding memorabilia. I want to photograph whatever helps convey the wedding-day spirit. I also take a few exterior photographs of the home to help chronologically organize and establish the scene for the series of photographs that follow.

Because the standard photographs of "mom fixing the veil in the mirror" or "dad helping with the garter" have grown old, I avoid them and capture what actually happens instead. If I am asked by the bride or family for advice or direction, I gladly oblige, but my modus operandi is to remain quiet, to observe, and to document.

Denis Reggie

The moments before the wedding are good opportunities for favorite photographs.

There are, of course, some necessary exceptions. To minimize the number of formal photographs that will be needed after the ceremony, I might attempt to quickly gather persons for any group photographs that have been requested by the bride. It might be the bridesmaids or maid of honor with the bride, the immediate family, perhaps the flower girl or grandparents, or even the bride alone for a moment. If time permits, I photograph the bride as she leaves home, heading for the limousine with her father. Then it is off to the church to photograph the nervous groom.

Upon arrival, I greet the groom and also ask that he "relax and forget that I'm around." Before the ceremony, I can hopefully capture him pensively waiting in the minister's study, or exchanging stories with his dad or best man. I might gather his ushers, best man, grandparents, or the immediate family for quick group photographs, helping to speed along the after-ceremony photography.

For the all important exchange of vows, I try to photo-graph the couple and minister from a hidden vantage point using a tripod-mounted camera.

It is important to remember that the wedding day was not instituted as a grand portrait session. By working quickly (with a smile and pleasant demeanor) and minimizing the number of posed groupings in favor of less formal, candid shots, you can document the day by showing the spontaneous excitement of the participants and family members. Keep in mind that many people find posing to be imposing!

The Ceremony
Compared to the number of photographs taken before and after the ceremony, those taken during the actual ceremony represent the smallest portion of my overall coverage. This is not to say that the marriage rite is less important than the other moments. In fact, out of my respect for the sanctity of the service, my intention is to document only key moments, avoiding excessive noise or visibility during the actual wedding.

Denis Reggie

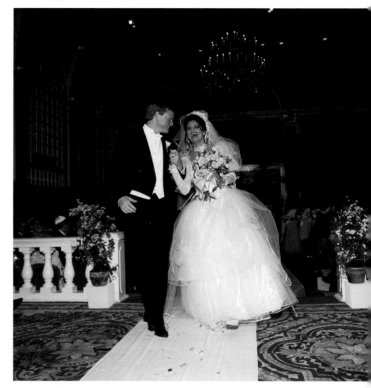

Be prepared—a great reaction like this should not go unrecorded.

Regardless of church rules, I do not take flash photographs during the ceremony. I use my flash unit (very likely with the Pocket Bouncer attached) to photograph the mothers being escorted up the aisle (positioning myself toward the rear of the church to minimize visibility), and then switch off the flash until the newlyweds head down the aisle at the end of the service.

For the all important exchange of vows, I try to photograph the couple and minister from a hidden vantage point using a tripod-mounted camera. If the church or synagogue has incandescent (tungsten) lighting, KODAK VERICOLOR Professional Film, Type L (VPL) in the HASSELBLAD is my choice. My exposures are computed with my camera's built-in meter; a typical setting might be $\frac{1}{15}$ second at f/4.0.

If the illumination is daylight from windows, I opt for the KODAK VERICOLOR 400 Film (VPH). Occasionally, I position my 35 mm camera equipped with a long telephoto lens (perhaps camouflaged behind flowers through a doorway adjacent to the altar) to photograph members of the wedding party and families during the service, without subject awareness.

I consider both the balcony and ground level for scenic overviews, and to add variety, I make exposures from several positions using different lenses. Remember that with even the quietest cameras, judicious timing must be exercised in releasing the shutter. Avoid clicking during moments of total silence whenever possible.

At some point during the service, I quickly exit to an outdoor position with my tripod-mounted camera and 50 mm lens to take a few exposures of the church exterior. Using VERICOLOR Professional Film, Type L for night weddings, my exposures could be up to 45 seconds at $f/5.6$ for buildings that do not have exterior lighting, and somewhere near 5-second exposures for normally lighted exteriors. Even though the film has a wide exposure latitude, I suggest making exposures at various settings to explore different effects. For daytime events, my exposures of the church exterior are made on VERICOLOR 400 Film with my camera set according to the built-in meter.

Formal Photographs

Couples' tolerance for lengthy, wedding-day portrait sessions has diminished over the years. The idea of detaining the celebration for half an hour (I have even heard of 90-minute restaging and group photo sessions!) wins little favor with the couple or the wedding participants, not to mention the waiting guests.

Creating all of the formal photographs before the ceremony has also gained little acceptance, especially with traditional couples who wish to save their first glimpses of each other for the actual ceremony.

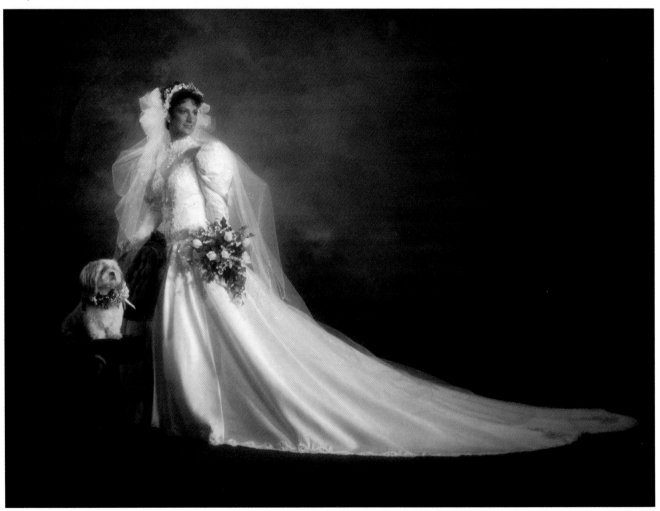

Carefully controlled lighting and exposure permitted a straight print of this image. That meant savings of time and money, and improved profitability for the studio.

Larry Sengbush

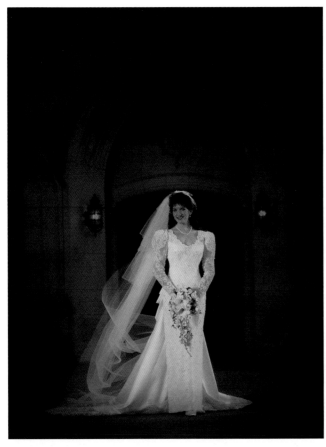

Two portable flash units illuminated this stylish, low-key portrait. The shutter speed was set to control the background detail.

There is no simple answer, but the first step in planning a speedy formal session is scaling down the number of different groups to be photographed. I favor less formal group photographs that are made quickly either before the ceremony or at the reception.

Portraiture is the art of creating lasting images of people. To me, everyone is beautiful. It is my job to bring out that beauty and then capture it on the film.

Though many old pro's find it unbelievable, I have diminished my list to only three post-ceremony, staged photographs: the couple, the entire wedding party, and the parents with the couple. By working quickly, I can usually complete the session in about ten minutes, taking four to eight frames of each grouping.

In selecting the setting for the formals, I consider using the front of the church or synagogue, an outdoor area on the grounds near the church or the reception, or an indoor location at the reception site. I look for not only the most beautiful alternative, but the workability of the backdrop in accommodating the groups to be assembled there. I avoid the predictable line-up of wedding attendants by finding settings that permit multilevel placement of the subjects. A handsome staircase or a corner sitting area might provide the perfect answer.

I favor grouping bridesmaids and groomsmen as couples rather than segregating them on either side of the photograph. By placing bridesmaids toward the front of the group, I am able to highlight their dresses and bouquets. Groomsmen are placed immediately behind the front row and are readily visible through openings between the bridesmaids.

Adding a second light source is beneficial in indoor group photography because it creates a three-dimensional, facial-shaping effect. Subjects have a much greater presence in photographs created with properly arranged double lighting. I affix a second METZ flash unit to a fully extended, eight-foot light stand (using a ball-and-socket style joystick grip) and set the unit to emit one full stop more light than the on-camera flash unit. This second light is positioned at about 35 degrees from the camera location, aimed toward the far side of the group to avoid overexposure of those persons closest to the second light.

David Ziser

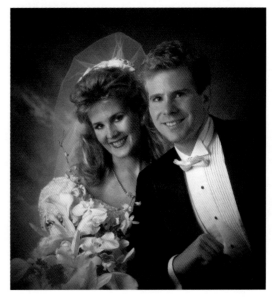

A vignetter on the camera and adjustments in printing darkened the edges of this image to add impact.

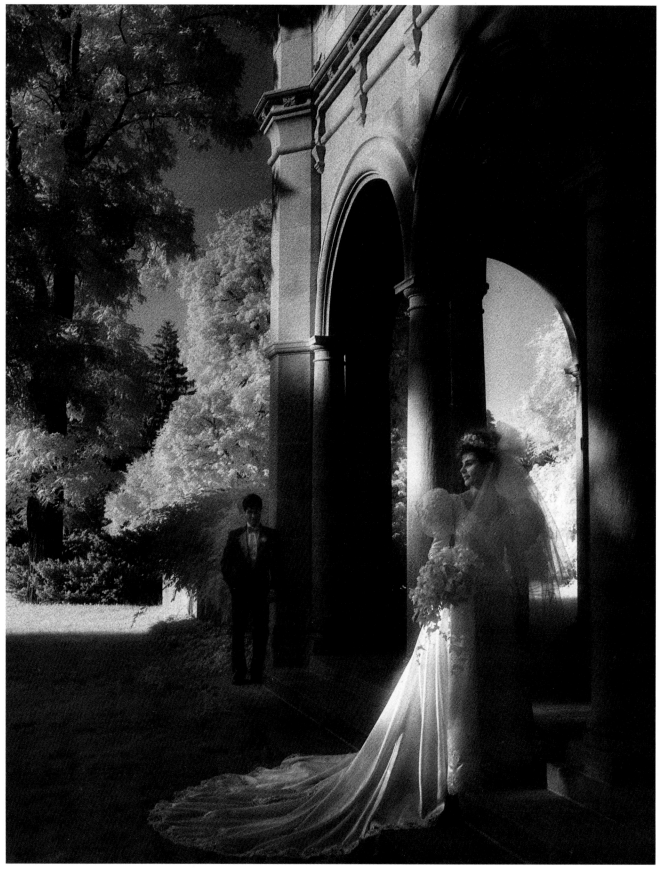

An unusual and effective treatment made on infrared film. © Kenneth Sklute, 1991

Usually, my on-camera flash output and the camera's lens will be set at *f*/8, while the second unit is set to emit a more powerful *f*/11 light level. I accomplish flash synchronization by either a photo-slave or a radio control device.

In actuality, the second flash is over-exposing the highlight side of the subjects, creating the desirable dimensional lighting pattern. The exposure latitude of VERICOLOR Film is quite sufficient to handle even greater highlight-to-shadow lighting ratios, but I find the one-stop variance to be ideal for wedding groups.

A word of caution is in order. Because the second flash is more powerful, it will produce shadows. Therefore, it is impor-tant that you position the second light precisely to illuminate the entire face of each group member. With practice, the positioning of the light stand and aiming of the flash unit become nearly automatic.

I have also used a 400 watt-second PHOTOGENIC PORTAMASTER umbrella lighting system on occasion as my second light. Though the unit is slightly bulkier and requires an electrical outlet, the results are excellent. Another popular option for double lighting is having an experienced assistant hold up the second flash unit.

When I use an outdoor, daytime setting for the group photography, I use my on-camera flash unit as the fill in light source.

When I use an outdoor, daytime setting for the group photography, I use my on-camera flash unit as the fill in light source. Setting my camera according to the light meter, I allow the existing daylight to act as the main exposure and light source, while I adjust the fill flash to come in at one full stop less. The resulting photographs have a natural daylight quality, without the harsh facial shadows typical of outdoor available light photographs.

If, for example, the existing light exposure is ½₅₀ second at *f*/11, I would set my camera accordingly, but I would diminish the flash output to a level equal

David Ziser

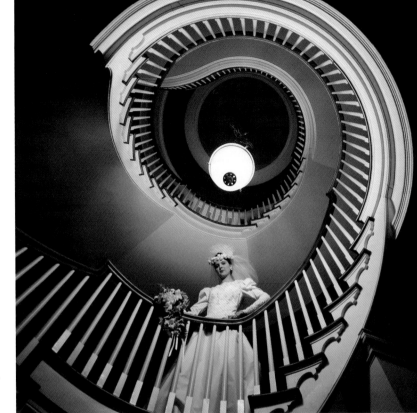

Another effective use of architectural elements working well with a viewpoint not common to most bridal photography.

to only *f*/8. For automatic flash units, you would accomplish this by setting the unit to *f*/8; for TTL flash systems, the film speed setting on the camera is doubled (to ISO 800 in the case of VERICOLOR 400 Professional Film).

To further soften the fill light, I attach a LUMIQUEST POCKET BOUNCE device to my flash unit; for late afternoon situations, I additionally affix gold material to the surface of the device to better match the existing warm daylight.

The Reception

Because so much planning and effort has gone into the reception, an important part of my assignment is to document the details of the setting. Relying on my tripod-mounted camera, I photograph numerous overviews of the reception area and close-ups of the decor, usually making exposures with only the existing light.

As a photojournalist, most of my action photographs of the festivities will be without active subject awareness. My best candid photographs occur during the second half of the reception because most people have then relaxed and become less aware of my presence. I move quietly with my camera held low, watching as the guests and family members mingle.

I avoid asking the subject to look my way, or "hold still" because I find those photographs stiff and unnatural.

When I find something noteworthy happening, I quickly raise my camera as I approach, occasionally firing without bringing the camera to my eye. Because of the depth of field of wide-angle lenses, I am able to successfully estimate shooting distances. I avoid asking the subject to look my way, or "hold still" because I find those photographs stiff and unnatural. When the camera is discovered by the intended subject, facial expressions become contrived and uneasy.

Denis Reggie

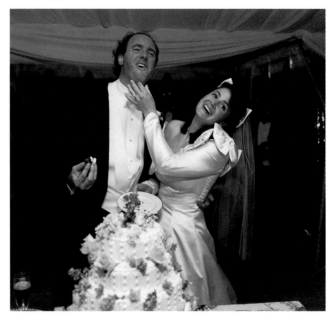

The best candids often occur late in the reception when people are more relaxed and natural.

While remaining low key, I offer suggestions to the bride that "it might be an appropriate time to…" perform a particular duty. As a hired professional, my mandate is to be of service, not in charge.

Rather than place the couple's hands on the knife and orchestrate the cutting of the cake, I prefer, when necessary, to give simple instructions before the couple approaches the cake table. Keeping my distance, I then document the event as it naturally happens. My lens is not only on the cake and couple, but also on the cheering spectators.

Remember that quickness is imperative to the success of a wedding photojournalist. If a grandmother grabs the bride's hand for a peak at the ring, I want that moment on film. If someone raises his own camera to snap the couple, a photograph of the photographer might be memorable. Finding and capturing interesting and unexpected moments is the mark of a sensitive photographer and is sure to win the praise of the wedding couple.

Denis Reggie

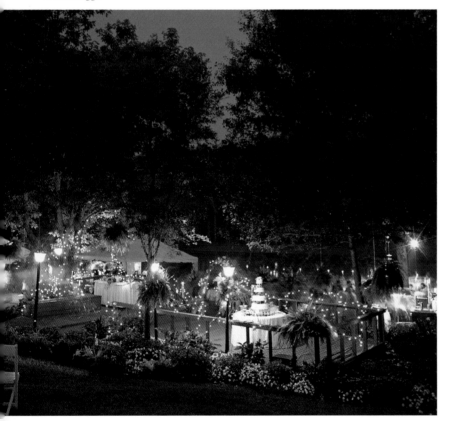

Don't overlook the opportunity presented by a beautiful reception site such as this.

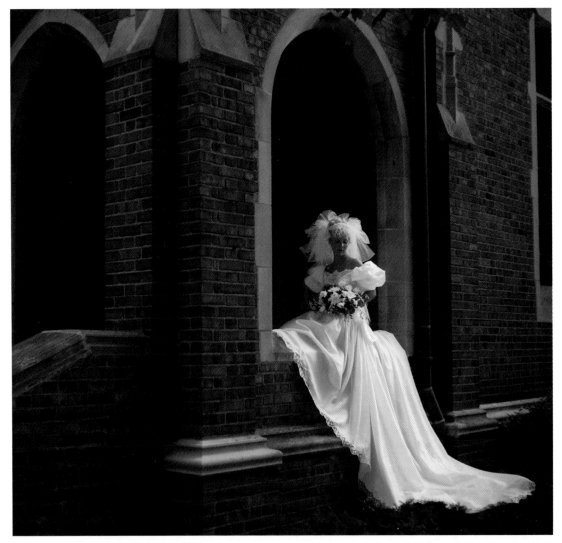

The background, the pose, and the careful placement of the train all add to the beauty of this formal portrait. The exposure was made by natural light.

I enjoy capturing the emotions of the couple as they bid their parents farewell at the end of a long day. After documenting the dash to the waiting car, I end my coverage with a study of the aftermath, perhaps a close-up of the rice or flower petals that now adorns the sidewalk.

Follow-Up

When the wedding day is over and the couple is relaxing on some beautiful beach, Monday morning begins the start of the next phase of the assignment. In terms of working hours, wedding-day photography constitutes but a fraction of the complete assignment. The post-wedding production begins by sending the film directly to a trustworthy color lab for developing and proofing.

Some photographers, particularly those employing the traditional, portrait approach, have achieved success in selling photographs as beautifully arranged slide presentations, often choreographed to music. Instead of having typical, "paper" proofs printed from their negatives, these photographers have the lab produce a type of color slide (sometimes called "transvues") from each negative.

Because first impressions are so important, this method allows the client to initially view each image as a "wall portrait" by projection into an actual frame. An important benefit of this technique is having the decision made at the time of the presentation. The limitations of this system include the difficulty of arranging a session with out-of-town clients and the amount of time required for the actual selling.

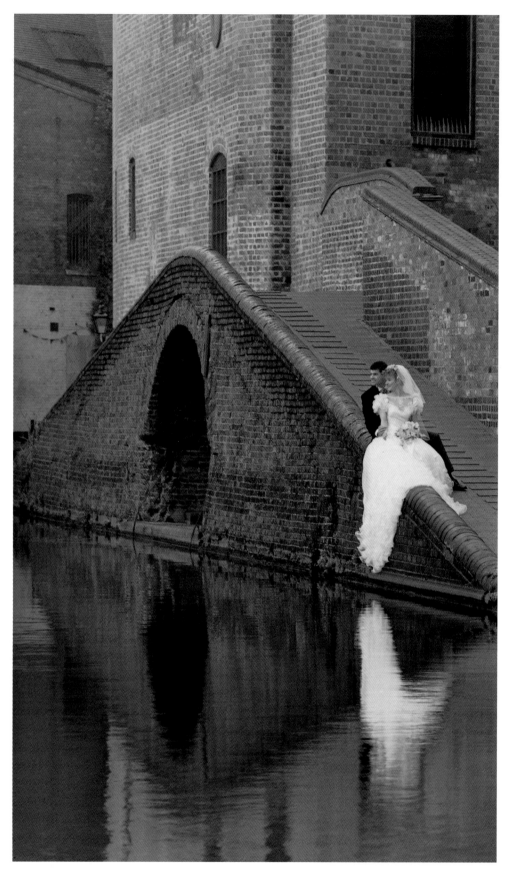

A soft and delicate portrait that is all the more effective because of the romatic canal-side setting.

John Brooks

As a photojournalist, I sell complete plans which include the finished photographs in custom albums. At the time of the booking, my clients choose from several plans that vary in the hours of coverage, number of photographs taken, and the size and number of albums. My system does not require me to actively sell after the wedding.

My clients view the originals (5x 5 or 3½ x 5-inch size depending on which camera I used) in professional proof albums and are asked to return them, listing their favorites. As part of my service, I design the layout of each wedding album using their selected images. Relying on the couple's suggestions or instructions, I determine which photographs to enlarge or group together on each page. The finished album is an artistic blending of quarter-, half-, and full-page images, presented much like magazine coverage of a special event.

Professional wedding photography can certainly be lucrative, but not as rewarding as the satisfaction realized in preserving forever one of life's most majestic moments.

Once designed, I then fill out negative glassines with the appropriate quantity and sizes of photographs needed. As an added safety measure, I write my name and the job name on each glassine.

Most professional labs also supply aperture cropping cards for attaching each of the negatives. This affords the photographer an easy way to precisely communicate the desired cropping to the lab. And because color balance is subjective, I advise that you send sample photographs of the desired color tone to the lab for reference.

While the photographs are being printed, you can order and prepare album covers and pages. There are several professional album sources, most requiring simple assembly of the page inserts and cover.

Library-bound album styles offer another level of quality to the photographer. For these leather volumes to be produced, it is generally necessary that the photographs be forwarded to the bindery for the custom process. Any added effort is handsomely repaid in the exquisite quality of these albums.

Throughout the cycle of a wedding assignment, a successful photographer wears the hat of artist, designer, salesman, technician, and businessman. Professional wedding photography can certainly be lucrative, but not as rewarding as the satisfaction realized in preserving forever one of life's most majestic moments.

Paul Wilmshurst

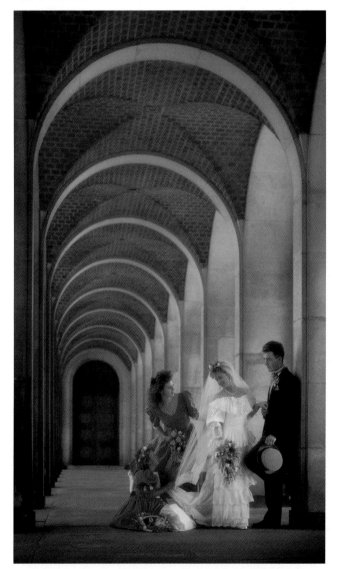

Shot at the wedding, not set up beforehand, this photograph proves the value of being prepared for special moments as they present themselves.

FASHION MAKE-OVERS

BY JOHN AND TRISH PERRIN

When we started our business, fashion make-overs didn't exist. The average-looking woman believed that the faces she saw in magazines, movies, and the portraits on our walls were women who were beautiful all the time; they were natural beauties.

Most women never dream that there is a bridge between reality and the fantasy they see. They don't know what goes on behind the scenes or that anyone can look great with the help of a team of professionals. This includes the makeup artist and a stylist, along with fantastic wardrobes and the magic a photographer can create on film.

Therefore, our first step is to "educate" our prospective clients who are average women. We want to let them know (1) that this service is available to them, (2) that we can make anyone beautiful, (3) how easily they can achieve a look of beauty, and (4) that it is actually fun to have a makeover and be photographed—it's fun to play "dress-up" for the afternoon and to capture these illusions on film.

Before and After

Why before and after, you ask? To make people feel uncomfortable about themselves? Quite the contrary. By using "before" and "after" photos of real people in our ads, promotional pieces, and studio albums, we are able to break down the emotional barriers which interfere with our clients' ability to enjoy the makeover experience and, at the same time, to build their confidence to book an appointment. When they see the "before" and "after" photos, they can not believe the results.

We always make a "before" photo of all clients. The photos are not for the clients themselves, but for showing friends and relatives. They are amazed when they see the magic we have created in the "after" photo. It works!

Our average woman client is 30 years old, married, and enjoys a comfortable lifestyle. The last professional portrait she had made is probably her high school graduation portrait. Usually, she would like to forget the portrait, as well as the 15-minute photo session. In her mind, being photographed in a dark, quiet camera-room was anything but fun. If the portrait was not flattering, she assumed that she was just not photogenic. It is this fear, you must realize, that holds back many prospective clients.

A beautiful glamour portrait is something most women would love to have. But in the back of their minds, there persists a lingering doubt: "Will it really work for me?"

For many of our clients, this is their last chance. We, as portrait photographers, have the ability and the responsibility to give our clients that once-in-a-lifetime feeling of being beautiful. We are able to use our creativity to give them self-confidence that will greatly affect how they see themselves for the rest of their lives. When people look good, they feel good about themselves and vice versa. We can make anyone look beautiful—anyone!

It is such a great feeling to make new friends and to have them tell you from the bottom of their hearts: "You have really changed my life!"

Pamela Stoll

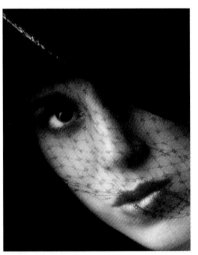

Photography can merge fashion and fantasy to change dreams into reality.

*An arresting image that shows off the subject's beautiful eyes to
full advantage.*

Michelle Aldridge-Allen

The Session

As the strobe heads flash away over the booming bass sounds of music jamming out the speakers, a glamorous woman wrapped in furs and rhinestones moves ever so slowly to the direction of the photographer behind the camera.

"That's great! Got it." *Flash!* "Got it. Okay, let's try the man's white shirt for a different look." She is whisked away as the set is changed to match her next look. She loses the fur and rhinestones as the makeup artist tones down her evening-wear look to a more casual look. Within ten minutes, she is back on the set. But this time, she is projecting a toned down, sensuous appearance. She wears a man's open white shirt over a pair of old, torn Levi jeans. She listens to every word and watches the photographer's hand as he guides her face to that "oh, so perfect" cover-girl look.

"Good. Now chin out slowly. Good, good. Now, chin down just a little. Great, great! Now just take a little breath through your lips. Yes. Eyes to camera." *Flash* "Hold it. Hold it." *Flash.* "Fantastic! Great! Cut. That's a wrap."

You might think you were on the latest set of a Calvin Klein model shoot or maybe a "Guess" ad. What you have experienced takes place hundreds of times a day,

All the elements in this photo combined to create impact. The color harmony of the headband, dress, and background produced the desired golden glow.

The mylar background accented the fashion pose and mood.

not only in commercial fashion shoots, but in portrait photography studios across the nation. The subjects are not professional models. They are "real" people, including housewives, business women, and secretaries who might never have posed for a professional photographer before (although it is not unlikely that many of them have fantasized about being a model or a film star).

Your clients can be stars for the afternoon, look good and feel good, and live the fantasy they thought they could never enjoy. Portrait photography has come a long way.

Welcome to the world of fashion makeover photographers, the latest rage in portrait photography. For anywhere from two to four hours, our average woman (or man) is totally pampered with specialized makeup, hair styling, fashion clothing, glamour lighting, and high-fashion backgrounds to have her (or his) own mini-fashion shoot. It is not for the cover of a magazine, but just for experiencing the fun or natural high of being a model in the limelight. Your clients can be stars for the afternoon, look good and feel good, and live the fantasy they thought they could never enjoy. Portrait photography has come a long way. But just as in any other medium, it must keep pace with the society that supports it.

Our clients are well educated about fashion photography through a constant barrage of TV and magazine advertisements. Fashion photography is everywhere, including hair salons, fitness centers, and fashion-clothing stores. These businesses all project the perfect "you" image. They also realize this perfect look is a created illusion and the product of a team of professionals. It is not reality. But it is attainable by anyone (if only for the afternoon).

Back in the Studio

After the photo session, our client views her newly-created image on the sales-room monitor and is swept away. She can't believe it's really her. "You look fantastic! Absolutely marvelous! Your boyfriend is going to go crazy when he sees these photographs of you. He will want to marry you on the spot. You look just like a model on the cover of a magazine."

What woman wouldn't want to hear these words of encouragement when first examining her photographs? She will look and feel beautiful, maybe for the very first time in her life. She will see herself in the golden image of cover models and silver-screen goddesses that she has envied.

Welcome to the world of fashion makeover photography.

Reality and Illusion

As society changes, so must we as professional portrait photographers. As new markets present themselves, we must strive to deliver those products our clients desire. Professional portrait photography provides the photographer with many broad and diverse opportunities. For the moment, we will discuss what, by most, is called traditional portrait photography versus fashion/glamour portrait photography.

Traditional portrait photography has always been, and will probably always continue to be, the cornerstone of our profession. The first objective is to capture an accurate representation of the subject. The second objective is to present a mood or feeling that gives the viewer more than a one-dimensional perspective of the subject's personality. Traditional portraits should evoke emotion (happy, sad, disturbed, love) from the viewer.

Fashion makeover photography is similar to traditional portrait photography only with respect to the second objective. That is, we as artists are trying to guide the viewer in defined directions by the mood we

create through the use of lighting, posing, makeup, and props. It is more difficult because the mood or image we are trying to project may be in contrast to the subject's real life image (as seen in traditional portraiture). Our objective in fashion make-over portraiture is to create a new image of our subject that suggests a side not normally seen.

On Broadway Photography

"Before" and "after" photos are a great way to break down barriers. They give prospective clients the confidence that you can bring out their glamorous side.

The simple setting and the glamorous pose were essential to the success of this romantic creation.

Carrie Evenson

Why Illusion?

Why would anyone want to look like someone else or show a side of her personality that is really not who she is? Clients may feel the need for a fashion makeover session for many of the reasons below.

Probably the number one reason clients enjoy fashion makeover sessions is for fun! Compared with traditional portrait sessions, fashion makeover portraits are fun and exciting. It is not the real us, but the make-believe fantasy side of ourselves. All of us have dreams. Some women dream of being the sultry screen star, or maybe the girl in the "Guess" ad. Some men dream of being James Dean in a leather jacket riding a vintage Harley-Davidson.

Dreams and illusions are all around us in everyday life. The visual images around us affect the ways we think and behave in society. So what better way to enjoy these fantasies than a "created" image in a fashion/glamour portrait shoot?

Some clients come to enjoy the fun experience of the fashion makeover photo shoot itself as well as the excitement of the final portrait.

It is great to know that our clients want to be photographed and truly have an exciting and fun time in the process. What more could we ask for as photographers? As we all know, the more our clients get involved in the photo session, the easier it is for us to guide and transform them into the fantasy world of illusion and beauty they desire.

Probably the number one reason clients enjoy fashion makeover sessions is for fun! Compared with traditional portrait sessions, fashion makeover portraits are fun and exciting.

Not only is fashion/glamour photography a great opportunity for you as the photographer to interact with clients, but it is a great experience in team effort from beginning to end. The whole photographic team must project the desired "fun" atmosphere so the client can let loose for the camera. If the photo shoot is fun for the photographer, makeup artist, stylist, and salesperson,

the client will feel the excitement of the team and experience it along with them. The sales process takes on the momentum of the excitement.

Also, when clients look and feel great, the sales selection process itself becomes a new "high" for clients. They'll want to come back for more, time and time again! Why? To enjoy the illusion of fantasy you created.

How It Starts

It all starts when clients first enter the studio. The sights, sounds, and activity give the studio an upbeat atmosphere which accelerates the emotional responses and lets clients know they are in for a special time. They gaze at the surrounding wall portraits of the average person, (who, in reality, is no different from the client) looking as if they just stepped out of a magazine. After a champagne greeting, we slowly let our clients unwind while looking through our "before" and "after" albums to get a feel for the poses they might like and to select either fashion/art black-and-white or fashion color photography. More than this, though, we are helping our clients to build up the confidence they will need

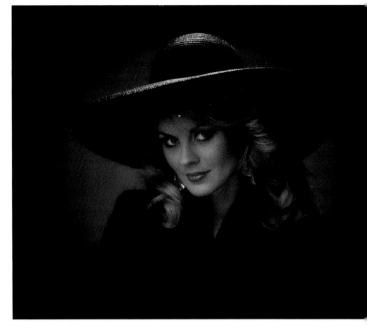

The lighting, composition, and even the hat worked together to focus attention on the subject's beautiful face and eyes.

On Broadway Photography

For romantic glamour, diffusion and muted colors compliment the subject and set the desired mood.

when it is their turn in front of the camera. By looking at the "before" and "after" photographs, we make believers of our clients and the trust begins.

At this point, the most difficult decision is whether to photograph as fashion/art black and white, which is simple and clean but very bold or to opt for softer, moodier color. After we find out who the portrait is for and what look our clients have in mind, we will guide them to the correct medium. Remember the client will always achieve a more dramatic change and look most like a model with the fashion/art black-and-white portrait because the dramatic makeup doesn't show in the finished print. You can apply makeup more heavily because the high-key, high-contrast black-and-white prints wash out the gray tones. In color, heavy makeup will show and therefore has its limits in the total process.

In all of our makeover photo sessions, we have our clients pick out three or four new, exciting looks they desire. Clients choose from fashion/glamour, high-fashion, and romantic (or boudoir, as it is better known). Since most women want these photographs for the men in their lives, the glamour look is the most popular. Fur coats are the number one clothing choice. We have over a dozen poses from which to chose when wearing a fur. We have everything from soft and innocent to downright hot and sexy. You never know what the man in her life might like on the wall. A variety in poses covers all the bases.

In our normal photography sessions, we give our clients 20 to 30 poses from which to select. These will consist of up to four different outfits or settings. Even though we will concentrate on glamour looks, remember, our main goal in the session is to make it a fun and exciting experience by itself. Through variety, we help accomplish this. By staying with these proven principles, most of our clients will ultimately decide to purchase a beautiful, wall-decor portrait and will always remember the fun they had creating their portrait with us in a team effort.

The Fun Begins

The Formula—Makeup

At the start of each session, the client is treated to a personalized makeover under "Hollywood" lighting, by our full-time, licensed makeup artist. We use a personalized formula for each individual to obtain the desired results. The style in our photographs is the result of our unique formula that takes into account the combination of intensity of makeup, lighting, exposure, development, diffusion, film, focal length, aperture, and the type of look we want in the photo. All clients must have their makeup applied in the studio if we are to achieve success in the final portrait image.

On Broadway Photography

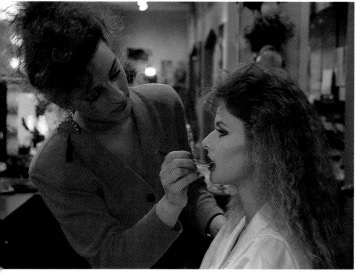

The fun of a fashion make-over begins with personalized styling and makeup.

On Broadway Photography

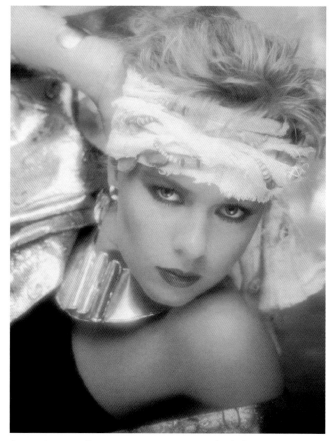

Proper image styling creates an exciting, new look that you can offer your clients.

When the diffused highlight on the client's cheek reaches a certain point or density, we know the makeup is perfect. We intentionally wash out detail in the nose and face, while providing deep, rich color saturation in the eyes, lips, and cheekbones. This is accented further by brilliant color in the background and clothing.

At the start of each session, the client is treated to a personalized makeover under "Hollywood" lighting, by our full-time, licensed makeup artist.

We direct the viewer's attention to the subject's eyes by use of makeup and camera focus. We always make an effort to put the main emphasis on the eyes; we want an interaction between the subject's eyes and the viewer immediately. Emphasis on the eyes combined with

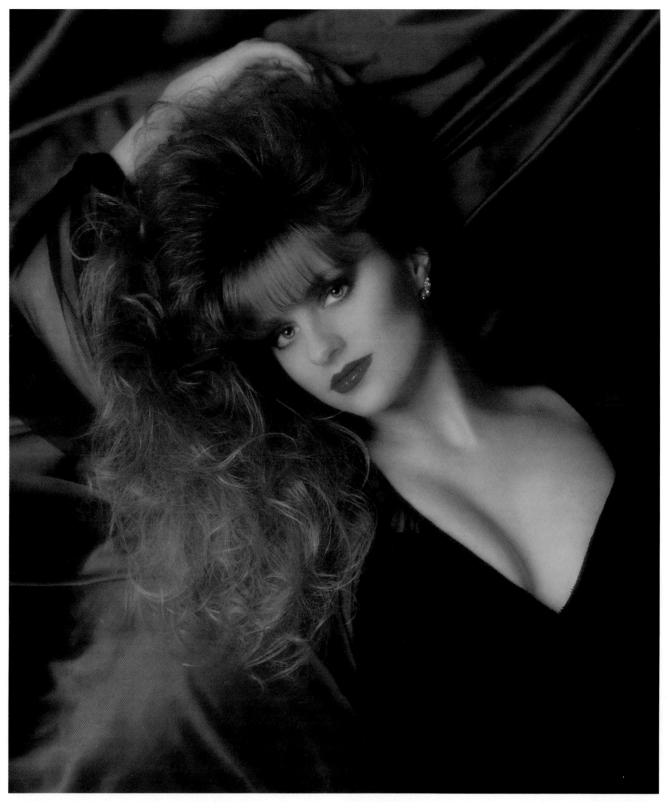

Satin sheets provided a soft, low-key background. Pillows under the sheets gave them contour and allowed the lights to pick up reflections in the fabric.

Carrie Evenson

slightly-parted lips create an aura of mysterious fascination. This combination of eyes and lips is what we call the "Vogue" look. It holds the viewer's attention and conveys a message at the same time. The message is realized quickly once we add the elements of clothing (neckline) and the pose. Quite simply, high-neck clothing conveys a casual feeling. Necklines with a slight V and a high collar say fashion. Any neckline which is low or off the shoulder translates automatically to glamour in the viewer's mind. We then match the neckline with an appropriate pose to further emphasize our statement.

It is interesting that the viewer first sees beautiful, intense eye; then looks quickly at the slightly-parted, pouting lips that lock in the fascination. Then the viewer scans the clothing and pose. It happens so fast in the viewer's mind—a fur off the shoulder, seductive eyes and lips. It says it all—glamour. If the viewer has a personal relationship with the subject, his mind, no doubt, will wander to seductive images even though only a bare shoulder shows. As artists and photographers, we have succeeded in our desired goal of creating a professional, beautiful, artistic image of our subject, while at the same time provoking the intimate emotions she hopes for upon giving the portrait as a gift of love.

It is a special relationship with client and photographer both working toward a common goal. It is built on trust and professionalism and, if so maintained, will carry through to the selection process. Selecting the

Carrie Evenson

Shot in front of a large dresser mirror, the windows were behind the photographer. The wallpaper was actually upholstery fabric.

Total image styling is vital to creating a flattering appearance.

appropriate image and size for the intended recipient is important. Wall portraits not only make our subject and our photography look its best, they convey the subject's intimate message to be enjoyed forever.

Besides our unique photographic formula, our success is built on the knowledge we are not just photographing a client; we are creating a personalized image designed specifically for her and the recipient. Using all of your skills and professional talents, you are going to "create" the illusion of beauty that we all hope for. It is up to you as an artist and photographer to not only direct your subject, but also to direct your team of assistants (makeup, hair, wardrobe) to convey that special message.

If you succeed, your client will love and trust you forever.

When They Look Beautiful, They Feel Beautiful

After approximately 30 to 45 minutes with the makeup artist, our client is looking and feeling beautiful. She has the eyes of Cleopatra. Eyes that demand attention. Eyes that could kill. She has lips she never had before, full and pouty. Lips that can't be resisted. What about those cheekbones? Cheekbones she could never seem to find before. She can not help but feel excited about the new woman she sees looking back at her in the mirror.

After scouting the location in advance, the photographer returned at sunset to create this golden portrait.

Jerry Costanzo

Where has this woman been hiding? No matter, she is here now. And as her hair is teased to its absolute fullness, she feels new energy coming from within. With the stylist, photographer, and her friends ranting about how great she looks, she feels ready for anything. She chooses the wardrobe with the help of the team, fur off the shoulders, long glimmering rhinestone earrings, gloves, and a diamond necklace. She is ready and she knows it! You have not only created a new look for her, you have also created a new person to wear it with complete confidence. It is the ultimate "high" for everyone there. See it all come together for total success in front of the camera. When her friend looks into the camera and exclaims: "I can't believe it, you look like you should be on the cover of a magazine!" I take the shot!

When the client reaches this point of excitement, I move with the emotional flow and keep her enthusiasm up throughout the session with verbal encouragement and attention to every detail of her makeup and wardrobe. It is this one-on-one personal attention and excitement that allows the client to relax. She knows everything is taken care of. She only has to let her newly found beauty shine and have fun!

At this point, it is not the lights, not the camera, but the one-on-one rapport between client and photographer that brings out the absolute best which can now be captured on film.

It is up to you as an artist and photographer to not only direct your subject, but also to direct your team of assistants (makeup, hair, wardrobe) to convey that special message.

Behind the Camera

The camera we choose is one that best delivers the optimum results in our finished product—large, canvas wall prints, in 24 x 30-inch size. We need a camera that has an automatic film advance, so we can use a hand-held shutter release to give the client our undivided attention. Also, automatic film advance is important as it does not distract from the photographer-client rapport. Most cameras using 2¼ x 2¾-inch film satisfy both of our requirements.

Duane Sauro

The sheer fabric and the low-key lighting worked together to produce a beautiful and sensual image.

Nowhere is negative size more crucial than in producing high-key, high-contrast fashion/art black-and-white prints. To achieve the desired contrast, we can only push the film so far before grain and loss of sharpness show up in large prints. Achieving contrast begins with the initial makeup application and continues later with the use of graded-contrast papers. But to achieve the fashion/art look, we also need to push the film approximately 1 to 1½ stops to increase contrast. This produces excellent results with acceptable grain and sharpness on large prints.

Since most of our clients prefer head-and-shoulder portraits, we almost always use a 180 mm lens on our camera. This is the perfect focal length for our typical head shots, as well as being the right distance from our subject in relation to the lighting and the depth of field.

Lighting
Fashion make-over lighting need not be complicated or complex. It is relatively simple for making head-and-shoulder portraits.

When working in color, we use a large, diffused, semi-directional light source to take advantage of the wonderful results it produces.

We use a 52-inch STARFISH or HALO light modifier powered at 100 watts as our key light and a single 36-inch MYLAR reflector under the face to fill in any shadows produced from the STARFISH. The STARFISH aimed straight at the face from three feet away, unfeathered, creates a soft, semi-spot of light on the face with gradual fall off over the cheekbone. The center of the starfish is approximately one foot closer to the face than its outside edges, resulting in a gradual fall off of light or vignetting on the lower shoulder area. Remember, we are only three feet away from our subject's face with the STARFISH. We also use a super silver reflector opposite the key light side of the face to diminish any shadows. All lights are approximately three feet from the subject, with reflectors just out of camera view.

Keep in mind that other lights with modifiers work well to create flat lighting. But, this is our preference for head-and-shoulders glamour photography.

When working in color, our preference is to use a 27-inch soft box hair light. We use an 8-inch reflector with a gel holder for the background light. Sometimes we use gels to project a certain mood in the photograph. The background light is also 3 feet from the background.

© John Drew

The pose accented this dancer's athletic grace. A soft-focus lens smoothed the hard edge of the direct lighting.

102

In contrast to traditional portrait lighting where we create depth and dimension with highlights and shadows from our lighting, in fashion makeover photography, we create depth and dimension by the use of light and dark makeup application. This also serves to enhance the best of our client's features and correct or minimize their imperfections. We bring out the best for the viewer with lighting and makeup in the illusion.

On Broadway Photography

An intentional one-stop overexposure lightened the diffused highlights in this subject's face for her high-school senior portrait.

In our fashion/art black-and-white photography, we use only our key light, the 52-inch STARFISH, at 6 feet from the subject. By increasing the distance between the subject and light source, we obtain a slightly-harder light source. This is our desired effect, since in fashion/art black and white we want a harder, bolder image. To further achieve this, we use less diffusion and a smaller aperture setting for greater sharpness.

Diffusion

In the formula that creates our "look" or total image control, as we prefer to call it, probably the most misunderstood and yet the most important ingredient is diffusion. The type of diffusion we use and the way it interacts with the intensity of makeup and quality and source of light is crucial.

When first drawn to fashion make-over photography, we read, watched, and attended every seminar we could on the subject. But, in the back of our minds, we always thought the magic ingredient was "diffusion." "Oh, yes," we'd ask, "what type of diffusion do you use?" Some used spherical aberration (glass diffusion) in front of the lens. But, there are a dozen or more filters on the market.

Which one should we use? Do we use the glass with dimples? What effect do convex circles give us? Does the size of the dimples or circles in the glass matter? What happens if we stop down from *f*/4 to *f*/11? What if we don't use glass but, instead, use plastic with diagonal lines, or a fog filter out of plastic?

It all comes down to the statement that you want your portrait to make and which diffusion creates the mood to carry out your statement. Should the portrait

In the formula that creates our "look" or total image control, as we prefer to call it, probably the most misunderstood and yet the most important ingredient is diffusion.

be sharp, diffused, or somewhere in between? What one person interprets as "soft" may seem sharp to another person; it is all in one's interpretation.

When making fashion makeover color portraits for clients (not professional models), we usually use diffusion. The varying degrees of softness add to the mood of the photographs, as well as conceal complexion imperfections. Fashion poses will be diffused slightly, but nowhere near the degree of a glamour pose, e.g. where our client is wearing a fur off the shoulder. For a lingerie shot, the diffusion will be even greater. And when creating artistic nudes, the diffusion should be greater yet. We feel that this softness helps set the mood to be interpreted by the viewer.

Basic fashion lighting with dramatic results. A softbox overhead and a large reflector below bathed the subject's face in light.

Charlie Palek

Carrie Evenson

The subject was seated in profile looking directly toward the camera—a visual effect that slimmed the body and emphasized the line and shape of her legs.

In direct contrast to color portraits, our fashion/art black-and-white portraits are simple, clean, and bold. For this reason and the fact that we want to create and hold contrast in the negative, glass diffusion or spherical aberration is the wrong choice. Glass spreads highlights into the shadows or, quite simply, cuts down the contrast. Instead, we use black netting or neutral density diffusion in front of or behind the lens. This diffuses slightly

Our main goal in fashion makeover color photography is softness with contrast to give the photographs impact.

while holding the contrast, and softens the edges slightly (depending on how many layers you use). You must consider an exposure loss of one-half to one *f*-stop when using neutral-density diffusion.

In fashion/art black-and-white, the color of the makeup does not show. However, since makeup shows in color photography, you'll have to rely more on diffusion, shadowless, soft light, and a large lens aperture to help in creating that beautiful face.

Charles Lenzo

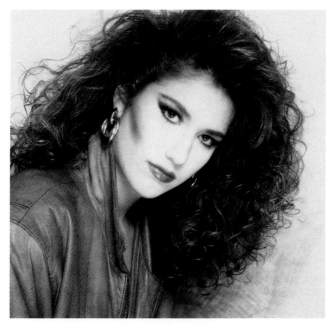

Black-and-white images are well-suited to a glamorous, high-fashion treatment. Special makeup provided the porcelain look of the face.

When making photographs in color, use nothing but the best glass. You will lose contrast with poor glass or plastic. Good-quality glass spreads the highlight edges into the shadows while holding the contrast. This occurs where the light rays strike the imperfection area or your

Colin S. Miller

Fashion makeovers embrace many moods from the dramatic to the delicate.

glass, be it circles or dimples. Where the light ray of your image strikes the clear glass, you will retain sharpness of image. So alas, you will spread highlight in the shadow area diffusing your image, but still retain contrast. However, with poor glass or plastic, the total image or light ray is distorted. Our main goal in fashion makeover color photography is softness with contrast to give the photographs impact.

A facial wrinkle is really nothing more than a highlight and shadow. First, we try to fill the wrinkle with makeup to give a flat, diffused highlight. Second, we create flat, shadowless lighting to diminish the highlight and shadow edges. Finally, by using spherical aberration (diffusion), any remaining shadow edge is minimized by spreading the highlight edge over it.

As you can see, it does take all three ingredients for our formula—makeup, shadowless, soft light, and diffusion to achieve the desired effect without losing contrast.

Image Styling

We are going to create a new, exciting look for our client. It is a look that is attainable, if only to be captured on film in a fleeting second. But, it is to be admired for a lifetime.

We refer to the transformation process as "image styling." Image styling consists of makeup application, hair styling, wardrobe selection, and background and set selection.

With the proper use of image styling, we as artists are able to create the fantasy or illusion our clients desire.

For color photography, the makeup is highly personalized. The colored gels used for hair along with the makeup must coordinate with the wardrobe selection and background color and fabrics (color key). It must all work together to create a unified statement, a harmony of color or color key. Most of our fashion makeover color is aimed more toward high-key, which comes across as a soft, dreamy, romantic mood. We choose color key and high-key in most of our portraits for this reason.

With a gel-covered hair light and background lights, it is very easy to match one's color key. When used with your backgrounds, these accent lights add depth, separation, dimension, color, and excitement to your portraits.

© John Drew

Two shoot-through style umbrellas provided the main lighting. The background illumination was one stop less than the main exposure for better separation.

Charles A. Leininger

Careful use of props, lighting, posing, and costume created this demure portrait.

It is what we consider a European-fashion influence, alive with emotion in stark contrast to the plain, gray backgrounds used in American fashion/glamour. The plain backgrounds might work well for models on a magazine cover. But, our average portrait would tend to come across as sterile and lifeless.

The colored gels used for hair along with the makeup must coordinate with the wardrobe selection and background color and fabrics (color key).

Besides the use of image styling along with color key, we try to create softly-diffused facial features, with the eyes as the heart of the look. By shooting at *f*/5.6 or *f*/4, we achieve a shallow depth of field with focus falling off sharply from the eyes, giving an additional softened effect along with the diffusion.

We use KODAK VERICOLOR III Professional Film, Type S. Besides producing beautiful flesh tones, it adds snap in our background color and sets. An additional

advantage of VERICOLOR III Film is its ability to hold these properties with expanded latitude. Most all of our film is pushed to 1 to 1½ stop to wash out the face highlights and still bring out the dark, rich colors. Only with VERICOLOR III Film have we found this latitude to hold both ends in our portraits without having color distortion.

It is our goal to put it "all on the film." In this way, we can be in total control of the image and not leave it up to the labs to interpret what we are trying to say in the portrait. Also, the first image your client sees is right on target without the need for retouching, dodging and burning, and diffusion during printing. Besides the money you save in lab costs, it gives you consistent, constant control in creating your portrait.

Boudoir Photography

When I think of boudoir, or romantic portraits as we like to term them, the same initial ingredients of image styling are required. There are a few additional considerations, however. First, we are dealing with three-quarter and full-length shots. Second, we want the portrait to look artistic and aesthetically pleasing rather than just revealing. It is for this second reason we like to call it romantic portraiture.

In addition to our basic ingredients of makeup, hair styling, and clothing, we will make adjustments in our lighting and diffusion to set the mood. In lighting our fashion faces, we want a flat, shadowless light, which works well with makeup to create depth and dimension. When dealing with the full-length shots, however, we will revert to traditional portrait lighting techniques of using highlight and shadow to flatter as well as add depth and dimension.

This is easily accomplished by using a four-by-six light screen at a 45-degree angle to our subject, while at the same time feathering the STARFISH to make flat, shadowless lighting. Along with this, we use maximum diffusion. To hold our color on high-key and color-key sets with this additional diffusion, we use KODAK VERICOLOR HC Professional Film. On our romantic set, the diffusion is three times as intense as our normal fashion/glamour set. VERICOLOR HC Film holds the highlights and helps retain the contrast even with the additional diffusion.

As in our fashion/glamour color photos, all of our wall portraits are printed on KODAK EKTACOLOR Professional Paper and given a very high-gloss spray to bring out the brilliant color and contrast we put in the negative.

Frank Cricchio

Boudoir portraits are usually a three-quarter or full length view, and employ more traditional portrait lighting techniques.

Fashion/Art Black and White

What is fashion/art black and white? It is a fashion make-over portrait of a subject—not that "everyday" person—but the fashionable and glamourous side of that person. By using a high-key, high-contrast black-and-white medium, it comes across as art rather than just a black-and-white portrait.

The advantages of fashion/art black-and-white photos are many, but the key element is that with heavy, black-and-white makeup and high-contrast graded papers you can, quite simply, perform magic. With this technique, you can transform average-looking clients into breathtaking beauties, giving them the most dramatic change possible. In addition, the nature of high-contrast black-and-white prints can be abstract or interpretive. Without the distraction of color, black-and-white prints can allow the viewer to focus more on the visual elements and connect with the emotion it evokes. This abstract nature along with the fact that we can create the most beautiful faces with this medium, makes it our personal preference for fashion makeover photography.

With the use of heavy, black-and-white makeup, we can hide any undesirable traits in our head-and-shoulder portraits and bring out the characteristics which are the real heart-and-soul of the photograph; namely, the eyes. When isolated, they cannot be denied. They pull the viewer into the photograph. When we downplay the complexion and nose detail, which can be distracting, the viewer's attention drops quickly to the "Vogue" lips. It is the emphasis on eyes and lips that utilizes the abstract nature and mysterious aura of this medium fully. With the pose and wardrobe in play, the mood is easily understood; however, the mystery of the eyes and lips continue to dominate the portrait. They are immortal, as we never tire of them.

The makeup artist creates the beautiful features your clients want. But more than creating beauty, you are creating the initial contrast needed in the final product. Without this initial creation of contrast in the face, you will be unable to produce enough contrast even with pushing the film and using the new graded papers. It all starts with the face!

Fashion/art black-and-white portraits are more abstract and are designed to show the fashionable and glamorous side of the subject.

On Broadway Photography

After makeup, you only need to match the clothing with the mood desired, be it casual, fashion, or glamour. The pose should convey the same message as the clothing. When this is done, you have a unified, clear and simple, yet bold image. We believe that a fashion/art black-and-white portrait is far more powerful than the same image in color.

When you hand-color the print with pencils or dyes, it takes on a presentation of art. The artist follows your guidelines on color and density, in order to establish the desired mood.

To obtain high-contrast images without extensive grain and loss of sharpness, we rely solely on KODAK PLUS-X PAN Professional Film along with dramatic makeup. With finer grain and higher contrast KODAK T-MAX 100 Professional Film, we can use less makeup. We underexpose the PLUS-X Film by ½ stop and push the development 1 stop in Process D-76. Our goal is

Kenneth Skulte

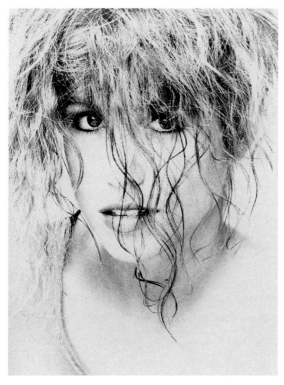

KODAK TRI-X PAN Professional Film was intentionally overexposed and overdeveloped to produce this highly stylized image.

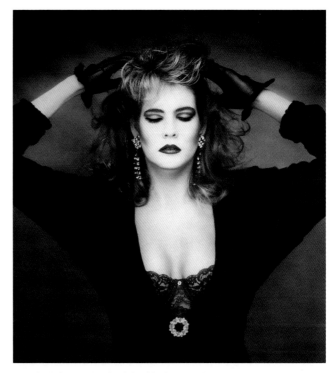

The high-fashion look of this black-and-white portrait was further dramatized by hand coloring the print.

repeatable, consistent-density negatives that will give us good contrast. We want blacks that are black and the correctly-diffused highlight density when we print on fiber-based KODAK ELITE Fine-Art Paper in a grade three. This allows us to use different paper grades to lower or increase contrast as needed.

Limited Edition Black and White

We take fashion/art black-and-white prints a step closer toward art with "Limited Edition" hand-colored black-and-white prints. We have always felt that fashion/art black-and-white prints are somewhere in between traditional black-and-white portraits and lithographs, which are associated more closely with the art field.

When you hand-color the print with pencils or dyes, it takes on a presentation of art. The artist follows your guidelines on color and density, in order to establish the desired mood. When you place these "Limited Edition" prints on canvas, you open new alternatives in wall decor for your clients.

Originally a color-tinted, black-and-white print, the result became part of a collage that was rephotographed on KODAK VERICOLOR III Professional Film.

The process starts with a bold, beautiful fashion/art print. Certain poses such as high fashion lend themselves more readily to the "Limited Edition" concept. Once you have the initial print, the artist applies light layers of retouching dyes with a fine-tipped brush. Another method requires application of a heavy coat of retouching spray first, to create a surface effect. Eyes, lips, and cheeks are lightly colored with oil pencils, PRISMACOLOR brand. To secure a lasting finish, a clear laminate or protective spray is required.

Euro-Style Black and White

Why not go all the way by taking the "Limited Edition" process one step further and make it a totally artistic concept? As we stated earlier, the very nature of high-contrast black-and-white prints is abstract, often open to the viewer's interpretation.

By applying water colors to the "Limited Edition" print, in an endless variety of shapes and sizes, our only limit is our imagination. Totally abstract in nature and way beyond the realms of portraiture, we introduce Euro-Style.

If you feel the artist from inside calling you, you'll need a good set of professional watercolor brushes and plastic paint used by cartoonists called CEL-VINYL. This particular paint adheres to glossy surfaces easily and you can clean the brushes in warm, soapy water. This allows easy corrections on the photograph. "Euro-Style," black-and-white portraits are totally unique in nature and, though their demand may be limited, their value is priceless when one understands and appreciates their evolution from fashion/art portraits.

Photographing Men

We have found fashion is "in" for men today, just as it is for women. Look around at men's specialty-clothing stores. Men today take advantage of beauty salons for hair styling instead of barber shops. Ten years ago how many young men did you know wearing fashion jewelry as well as earrings?

When it comes to male fashion portraiture, the main point to remember is that it requires completely-different techniques than used in women's fashion portraiture. With men you want a bold, dramatic, masculine look.

This basis of this limited-edition, black-and-white print was a bold pose designed to match the fashion styling and intended mood.

You want the viewer to interpret the portrait as "hard" versus the soft feminine portrait. For this reason, posing, lighting, and diffusion techniques used for females will not work well for male portraits.

To create your own personal style and learn about current fashions, study not only the leading fashion magazines of the United States, but also the best of

Glamour applies to men as well as women. Tastes usually dictate a bolder, strongly masculine look.

European rags. The majority of the major fashion trends originate in Europe, especially in Italy, the new fashion capital of Europe. Overexposure, out-of-focus images, and non-traditional composure or lighting are just some of the techniques used by photographers on tomorrow's leading edge.

In direct contrast to fashion photography of women, we seldom, if ever, use flat lighting with men. To create the bold, masculine look desired, side lighting with hard shadows works excellently.

Diffusion is slight, and one does not necessarily need "pretty faces." In fact, the "rough edge" is the trend today in most European magazines. Many times we ask the male subjects grow a slight facial beard to help achieve variety in looks as well as give them the tough look. Our preference in male fashion portraits is high-key, high-contrast black and white.

Closing

The fashion/glamour make-over photo-session is the newest and hottest concept in portrait photography. Not only does it include the boudoir element so popular today, it offers much more variety and excitement. It has something to offer every woman interested in the fashion trends so prevalent today. When was the last time you had a client tell you a photo session was the most

To create your own personal style and learn about current fashions, study not only the leading fashion magazines of the United States, but also the best of European rags.

fun she's ever had? What woman wouldn't want to experience the excitement of being a model for a few hours? The sights, the sounds—to feel the excitement in the air as she lives the fantasy. We are fortunate to work in such a diverse profession, with so many niches to explore within professional photography.

More than anything else, you must love people and be able to understand them, as well as gain their trust and confidence in a short time. Once you have that trust, you can use all your talent to create the images that will live in their hearts forever. When you capture that "magic time" in their lives, help them look and feel good about themselves, and open doors they never knew existed, you can not help but enjoy your work and feel good too.

When you really love what you do, there is no limit to what you can accomplish.

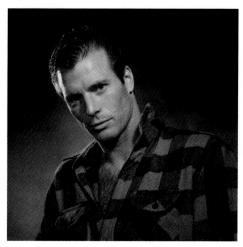

In many ways, there is greater flexibility in portraying men than there is with women.

PRESENTING PORTRAITS

BY DON BLAIR

The making of portraits is often the center of the vision of any photographer or studio. Composition, exposure, lighting, setting, cameras, and film are essential elements of a fine portrait, but they are only the beginning of a successful sitting

A conscientious photographer must look at each of these elements separately, and then consider how they will all come together in the final presentation. The value of a good presentation should not be underestimated. It is often the difference between a successful showing resulting in significant sales, and a mediocre showing followed by disappointing sales.

The presentation of the image begins once you have made the final exposures and you have promised the delivery of previews. It is here that you or your staff must explain the process that follows the sitting so that your customer knows what to expect. It is essential that your customer understand there are several steps in the process and that he or she is an integral part of the process.

Customers will have to make decisions along the way, from the choice of images, size of images, mounting techniques, extent and type of print retouching and finishing, to the framing of the final pieces for display in their homes or offices. You, the photographer, will be there to offer options and present your professional opinion on what might work best. You should consider the available wall space, the number of relatives who might want copies, the decor of the customer's home or office, and the image that your customer is trying to project to friends, family, acquaintances, and business associates.

Duane Sauro

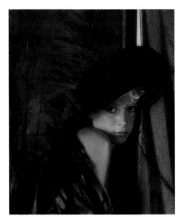

A combination of colored gels and filtration warmed and softened this portrait.

You can show the results of other clients and explain the array of services you offer, from mounting and texturizing to framing and displaying. You can, after determining where the customer will display the image, offer suggestions on the best size for the viewing distance or the most-appropriate frame for the decor of the room.

Remember, this is where that you can make a positive impression on your customer and others who will view your work. You must take every opportunity to present your work in its best light.

The Preview Presentation

This step in the presentation process is perhaps the most critical in determining the success of your efforts in the studio. This is the customers' first opportunity to actually see what they have only been able to imagine until now. The key is having your customers walk out of this session feeling satisfied. Your customers should feel that your camera has captured them at their best.

There are many ways for you to present your previews and each way has its own merits. Select a method that feels most comfortable to you or your staff. It's important that your presentation be upbeat and polished. You cannot accomplish this unless your presentation method works with your personal style. In my own studio, I prefer presenting previews by projection, while a very important and effective salesperson on my staff prefers paper proofs for all of her presentations. So, the method does not really matter as long as the end result works for you and your customer is satisfied.

Paper Proofs

The presentation of paper proofs has been a preferred method for previews for a number of years. With the paper preview, you are presenting a representation of the final image to the customer, but without the benefit of color correction, retouching, and print finishing.

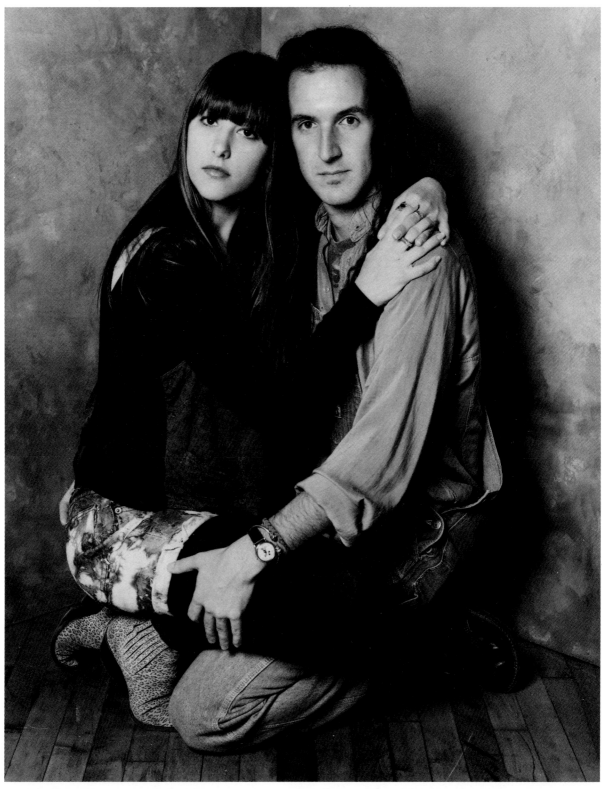

The intimate mood of a portrait such as this may influence how you present it and how your clients will display it.

© John Drew

It's a good idea to review and edit the results before meeting with your customer. Set aside any photos showing closed eyes, unattractive expressions, poor exposures, or awkward-looking poses. Present only those examples from the sitting that represent the quality you want associated with your studio.

This pre-sorted selection will enhance the review session and keep the meeting positive. Try to keep the anticipation level as high as possible. Because feelings are so important in the buyer's decision-making process, keep any possible negative feelings to a minimum.

Editing your work will ensure that your customers will be pleasantly surprised at just how great the pictures look. Reviewing the results ahead of time also prepares you for the presentation. You will be in a better position to help your customer choose the pictures best suited to his or her needs.

Don't underestimate the fact that your customers look upon you as the "picture professional." Your judgment is very important to them. Because you know a good pose from a bad one, customers will rely on your advice when it comes to making the difficult choices.

Because many labs have different processing and printing procedures, it is wise to check beforehand to ensure that they can provide the type of presentation you want. Some labs offer many options, which might include inexpensive machine proofs that are unspotted or better-quality machine proofs that include some spotting by hand. In the case of wedding candids, many labs offer special wedding packages that allow you to present your previews easily and professionally.

On Broadway Photography

A portrait-adorned reception area can work as a "silent salesman" and help boost profits.

David W. Stauffer, Leichtner Studios

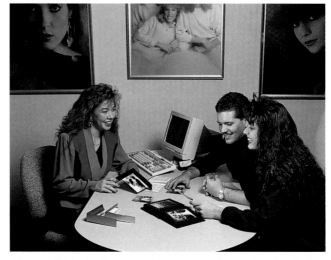

Clients will look to the you as the portrait professional and will rely on your advice when it comes to making difficult choices.

Labs often offer other services such as personalized previews with your studio logo and special portrait packages that include many different formats at a special price. You can present the previews in an album or in separate folders with your company name and logo on them.

Projection Previews

These type of previews are created by many labs for studios that prefer to project a transparency of the portrait sitting. These transparencies, often called trans-vues, offer you a more-dramatic presentation than paper previews. Because you view them by transmitted light, the image on the screen is more colorful and vibrant. The presentation takes on a special feeling.

Using transvues, you can present an entire tray of images or two trays with dissolves, along with music in the background to set the mood. After this first go-around, you can show the images more slowly and ask the customer to select his or her favorites.

You can use this approach to set the mood in a variety of situations. The mood can vary, depending upon age, social level, and the special occasion for which the photos were made.

For example, if a senior arrives to review her previews, it may be appropriate to play the same upbeat music that you used when making the photographs. It will help remind her of the fun she had during the sitting and it will reinforce the positive feelings and anticipation she had when she left the session. This also applies to wedding previews where you could play the couple's favorite song, or family portrait previews where there may be a particular type of music to which the entire

family can relate. Our business thrives on emotion and feelings. The effect of a darkened room with nothing but images on the wall really focuses attention and elicits warm thoughts.

There is another very important advantage to this type of presentation. By using a variable focal length or zoom lens on the slide projectors, you can actually simulate the final size of the image for the customer.

By using a variable focal length or zoom lens on the slide projectors, you can actually simulate the final size of the image for the customer.

Using frames with blank boards inside, you can show the customer what an 11 x 14-inch enlargement might look like compared to a 16 x 20-inch or 30 x 40-inch enlargement. This is surprisingly effective in helping the customer judge the difference among the sizes. As a result, your customers will avoid ordering too small an enlargement for an area that may require a larger size.

Keep in mind, however, that your customer is viewing the images by transmitted light and the final images will be printed on reflective (print) material. The transvues often look more vibrant and colorful than a print of the same image. It is important to point this out to your customer initially. You may save yourself some explaining when the final print is delivered. In addition, you will undoubtedly be saving your customer from disappointment as well.

One way to reduce the intensity of the transvue is to project the image on a screen that is not quite as bright or reflective as a standard projection screen. Try to use a color that will provide the same kind of reflectance that you would perceive when viewing a print on a wall. You can achieve this effect by testing several mixtures of paint. The paint color should be on the warm side to match the general warmth of the final image on paper.

Another tip to remember when projecting previews is to make the environment as comfortable as possible. Choose an area that has ample lighting and good lighting control so it is easy to dim the lights for the presentation.

Make sure that the seating is comfortable. Also make sure there is ample viewing distance from the projected image to provide the correct perspective in relation to how the image would be viewed in the home or office.

Don't forget that this is an important selling opportunity. Studies have shown that at this moment, when expectations and excitement concerning their photographs are highest, customers are most likely to place substantial orders, if pleased. Be ready to discuss preferred sizes and quantities for the order.

Marilyn Jetmore

Quality retouching can be vital to the success or failure of the finished portrait.

Retouching Portraits

When presenting the final prints to the customer, they must be as free from flaws as possible. This means that the prints must be "finished" by you or your lab. The final print may require simple retouching like removing additional catch-lights in the eyes or on glasses, reduction of reflections on a face that may have been too shiny. In some cases, more drastic changes are required.

These could include removing scars or birthmarks, or enhancing features such as drooping eyes or yellowed teeth. Remember, though, you should check with your customer first before making any changes. You may be changing the character of the individual against his or her own desires.

You can accomplish some retouching, like blemish removal, on the negative itself. This is the least expensive and most common method of handling such retouching requirements. Other types of problems, like catch-lights or reflections (light areas on the final print), must be retouched on the print itself because you cannot effectively retouch areas of high density on a negative.

When submitting portraits to your lab for retouching, be sure to provide clear guidelines and, whenever possible, the marked-up proofs themselves.

Mounting and Matting Portraits

There are many ways to mount prints for final presentation and for wall display in the customer's home. Prints should be mounted so that they will be protected and so that they will wear well over the years.

Some people prefer to dry-mount prints on various types of board. These boards can be made of heavy

Barbara White, Deuel's Photography

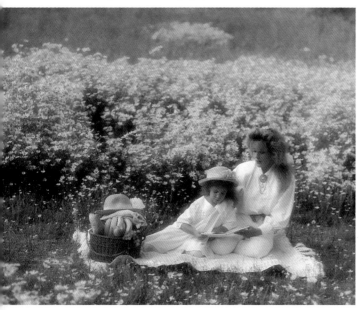

A traditional portrait style requires a type of display that is far different from more contemporary images.

MASONITE, art board, or FOAMCORE (a light-weight, foam-filled board with white cardboard sheathing). A similar material to FOAMCORE is known as GATORFOAM. With GATORFOAM, the foam is surrounded by an extremely durable and strong plastic material instead of cardboard. You can mount prints directly on to the material with a dry-mounting press.

An alternative to dry mounting is museum-type mounting and framing. This requires adhering the print to an acid-free art board with acid-free linen tape. The

The final print may require simple retouching like removing additional catch-lights in the eyes or on glasses, reduction of reflections on a face that may have been too shiny.

acid-free materials ensure that the print is not subject to the detrimental effects of acids in mounting materials which can deteriorate the print over years of contact. This type of mounting is often used in the fine-art fields where museums or galleries expect to maintain and exhibit important images for many years.

In addition to mounting the print, you may want to enhance the presentation with a matte. The whole "sandwich" is then placed under glass or PLEXIGLASS, and framed for display.

Another form of mounting is the canvas or canvas-board mount. This type of mounting is done in a dry-mount press. This type of mounting gives the final print the look and texture of a portrait or painting on canvas. Often the print is enhanced further with lacquers that bring out the texture of the canvas. Choices of lacquer textures include embossed linen or pebble, matte finish, luster or glossy finishes, or a painterly brush texture.

Framing Portraits

After the print has been mounted and/or matted, it is time to consider the type of frame that will best suit the image, the room decor, and the personal preference of the customer. The range and variety of framing materials is extremely wide. Many studios have a large selection of samples on display to help customers decide which is best for them and their families.

The type and style of the final print will help to determine how you should frame the photograph. For instance, it would be out of place to frame a very modern and radical pose of a high school senior in an ornate gilded frame. A better choice would be a more contemporary look, like sleek metal or a colorful, lacquered, wood frame. It is up to you to help the customer make such decisions. In the process, you will enhance the quality of the image.

Look through a number of framing catalogues for ideas on frames and how they compliment different types of portraits. Another source for ideas is your color lab and your local and national trade associations offices and the convention exhibits they hold.

Donald Mills

This type of image is a logical choice for a wall-size presentation.

Special Presentation Techniques

We usually think of conventional photographic prints on paper when we think about displaying prints. Today there are other ways to present photographs. The alternatives can be ideal for some special applications, both in the home and in other settings.

For instance, a family might like to display a large group portrait in a recreational room. To really show off the image, you might suggest using backlit materials like KODAK DURATRANS®, KODAK DURATRANS RA, and KODAK DURACLEAR™ RA Display Materials. Another option is KODAK DURAFLEX or KODAK DURAFLEX RA Print Material. While these types of displays may be somewhat unusual for a home, they offer an interesting approach. More typically, you might use these materials for corporate clients that may wish to display portraits of key executives in the lobby of the home office. For this type of application, these durable materials are ideal.

Black-and-white or hand-colored black-and-white prints are another unique way to display portraits. They offer a totally different approach and lend a certain style to a personal and compelling portrait that will hang in a prominent location.

© Nancy Keszthelyi, 1991

There are many sources of information to guide you in selecting a matte and frame appropriate to the mood and style of the photograph.

Tim Walden

This image was printed on KODAK ELITE Fine Art Paper and selectively tinted for the desired effect.

Dye transfer prints are an exciting medium that can enhance the look of a professional portrait. Dye transfer prints are exceptional in their color rendition and depth. They are also one of the most stable forms of photographic prints that will last for generations.

Display Considerations

There are a number of issues that you should contemplate when you make display decisions.

Lighting is one of the most important issues. Make sure there is adequate lighting for the photograph to reflect its full potential to the viewer. Also, the angle of

We are expected to be experts at making people look good. If we are to be taken seriously, then we need to make our own best impression right from the start.

light striking the photograph should not produce glare, making it difficult to view. Avoid placing photographs in direct sunlight, as this may damage the images.

The location of photographs is very important as well. Use wall space effectively. Try to create wall arrangements for multiple images in a way that flows with the decor of the room and the location of other items in the room. Make sure the location of the photographs relative to their size will allow proper viewing distance.

Finally, try to imagine a given wall arrangement. In other words, consider how many images may ultimately appear on a wall and the different sizes that could be used. For instance, a wall arrangement may include a large family portrait, smaller individual images that contrast characters of individuals (e.g., a baby's portrait vs. a teenager's). Create a layout before the actual picture-taking session that takes into account where the customer might display the final images. Present your layout to the customer when showing the previews.

This kind of pre-planning can take you a large step further toward pleasing your customer and translates to increased sales for your business.

Image Is everything

Remember that image is everything, especially in our business. We are expected to be experts at making people look good. If we are to be taken seriously, then we need to make our own best impression right from the start. I have found through years of experience that careful attention to details of how I present my studio's image to the public has made all the difference when I reflect on my successes at the end of each year. I am sure that you will find the same success if you remember to put your best image forward in everything you do, including the presentation of the portrait.

David Huntsman

This pond is actually in a garden studio. An outdoor setup can expand your photo options and increase your client base.

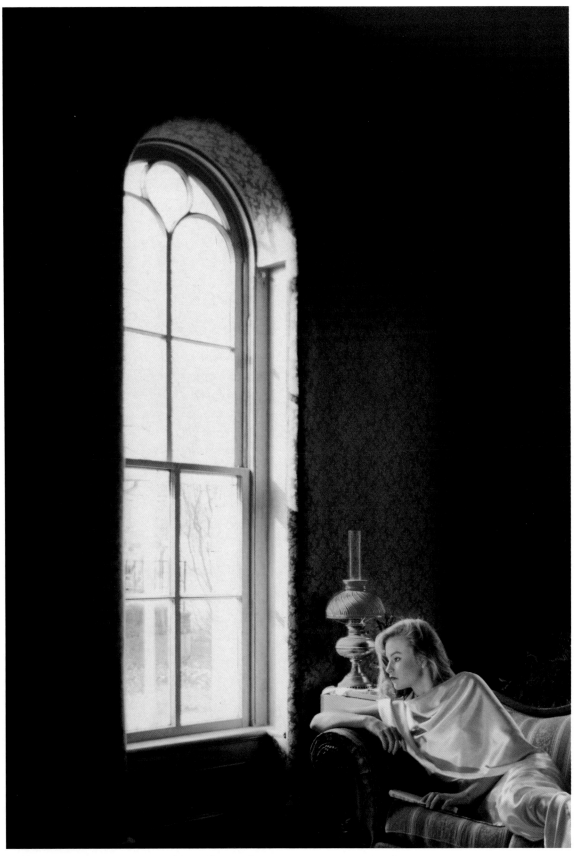

Wall-size portraits are impressive and they offer significant profit potential.

Hope Scarff

ABOUT THIS BOOK

The photographs in this book are entirely the work of professional photographers. Many of the images are from the 1992 PP of A Loan Collection. The editors of KODAK gratefully acknowledge the assistance and contributions of Professional Photographers of America, Inc., the Winona International School of Professional Photography, and the talented photographers and artists listed below. Our thanks to all of them for their willingness to share their images, ideas, and techniques.

Michelle Aldridge-Allen
Linda Bass
Rick Bauer
Larry Bilhartz
Clay Blackmore
Don Blair
Fernando Blanco
James Bowdoin
John Brooks
Tony Colomar
Jerry Costanzo
Dennis Craft
Frank Cricchio
Gregory T. Daniel
Jarvis Darville
Terry Deglau
John Drew
Larry Erickson
Carrie Evenson
Donald Fowler
Elma Garcia

Al Gilbert
Dennis D. Hammon
Doug Hoffman
Jolene Hume
David Huntsman
Robert Jenks
Marilyn Jetmore
Gerri Karamesinis
Tim Kelly
Nancy Keszthelyi
Edmund Lee
Charles A. Leininger
Charles Lenzo
David A. Lloyd
Jeff Lubin
Joe Marvullo
Kent McCarty
Terry McGrew
Colin S. Miller
Donald Mills
Geraldine K. Mitchell

Toni E. Moore
John Myers
Patty Oakley
Vincent M. Palazzolo
Charlie Palek
Katherine Dye Payton
Roxanne Pearson
John and Trish Perrin
Ed Pierce
Jennifer Price
Amy Rader
Denis Reggie
Stephen Rudd
Joseph Rush
Duane Sauro
Hope Scarff
Gerald Schlomer
Larry Sengbush
Elaine Sheckler
Boyce Shore
Beau Simmons

Ted Sirlin
Kenneth Sklute
Marijane Scott Smith
David W. Stauffer
Pamela Stoll
Michael Taylor
Rita K. Tinetti
James Travers
J.D. Wacker
Kurt Wade
Tim Walden
Karin B. Weber
Art Wendt
Gary Whelpley
Barbara White
Kathy Wierda
Paul Wilmshurst
Jon Wolf
William Wynn
David Ziser